CREATIVE DESIGN

STENCILLING
&
OTHER PAINT TECHNIQUES

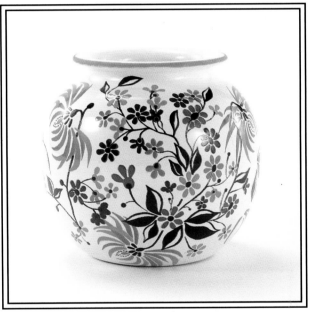

CREATIVE DESIGN

STENCILLING
&
OTHER PAINT TECHNIQUES

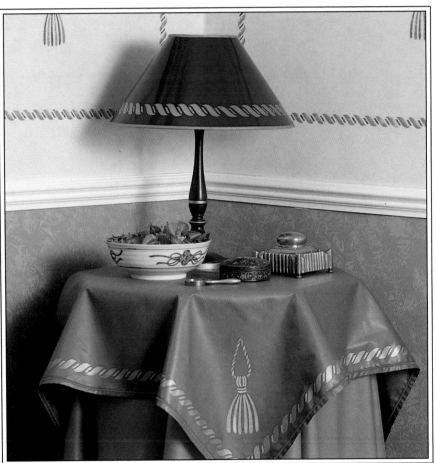

Caroline Green • Juliet Bawden

SMITHMARK

© Salamander Books Ltd. 1991
129-137 York Way,
London N7 9LG,
United Kingdom.

ISBN 0-8317-1864-1

This edition published in 1991 by SMITHMARK Publishers Inc.,
112 Madison Avenue, New York, NY 10016.

SMITHMARK books are available for bulk purchase for sales
promotion and premium use. For details write or telephone
the Manager of Specials Sales, SMITHMARK Publishers Inc.,
112 Madison Avenue, New York, NY 10016. (212) 532-6600.

CREDITS

Craft Designs by: Caroline Green and Juliet Bawden
Editor-in-Chief: Jilly Glassborow
Designers: Kathy Gummer, Philip Gorton and Tony Truscott
Photographers: Steve Tanner and Di Lewis
Typeset by: Barbican Print and Marketing Services, London, and The Old Mill, London
Color Separation by: Fotographics Ltd, London – Hong Kong, Scantrans Pte Ltd., Singapore
and Bantam Litho Ltd., England
Printed in Italy

CONTENTS

INTRODUCTION

Decorative Painting	6
Stencilling Designs	10
Other Techniques	58
'Freehand' Designs	76
Index	96

This beautiful book features over 90 original ideas for transforming your home using a wide range of decorative paint techniques. It opens with an introduction to the variety of paint products currently available from specialist craft shops and department stores, and looks at the many techniques you can employ. Following this, Section One concentrates on the popular art of stencilling, with stencil schemes for entire rooms – from living rooms and bedrooms to kitchen and bathrooms – plus a number of smaller, less time-consuming projects. Part Two looks at other popular paint techniques such a stippling, sponging, masking, marbling and potato-cut printing, and the book concludes with an attractive range of freehand designs in which you are encouraged to develop your painting skills.

You will find something here to suit every taste and level of dexterity, from easy projects for the less confident to complex designs for the more experienced. Each design is accompanied by colourful step-by-step photographs and easy-to-follow instructions on how to paint it, and many of the projects can be done in a weekend or evening. Where necessary, we have also provided patterns for you to follow, printed on grids so that you can easily convert them to the required size.

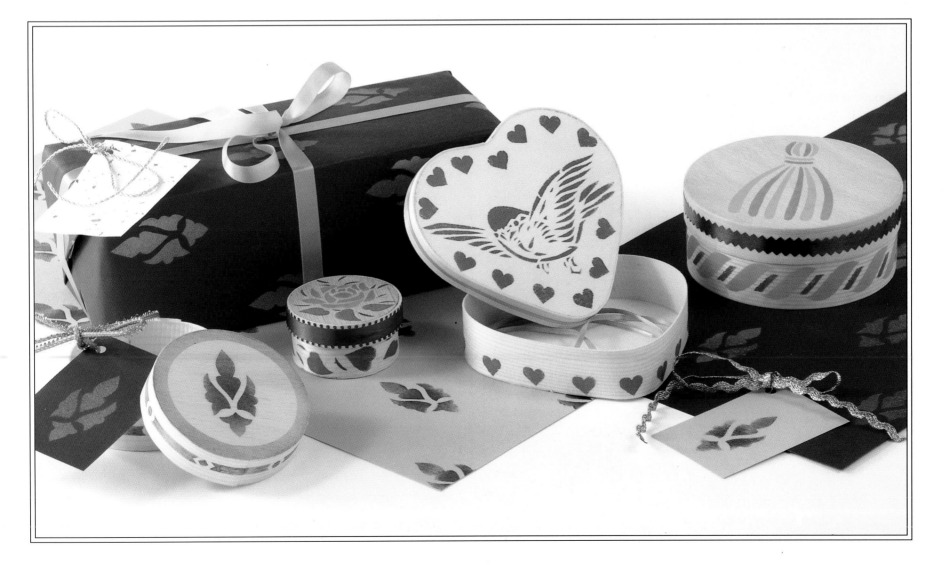

Enhancing plain or rather ordinary household items with the art of decorative painting is a truly satisfying and highly individual pastime. As the picture opposite demonstrates, the scope of what you can paint is virtually limitless. Ceramic plates, tiles, vases, picture frames, glassware, lampshades or plain boxes can all be transformed with a little thought and skill.

Many of the techniques have been applied to small household or personal items, but in the early pages of this book, you will find numerous ways of enhancing architectural features and decorating rooms with stencilling techniques. Walls, arches, beams and even soft furnishings can be decorated and co-ordinated to create your very own personal decor.

MATERIALS

In recent years, manufacturers have met the demand of the hobbyist by supplying a vast range of paints, pens, crayons and varnishes through craft shops or good department stores. Although various products are intended for use on specific surfaces, you will find that some paints work well on more than one surface. Always use good quality brushes and clean them immediately after use. Brushes used with a solvent-based paint should be cleaned in white spirit or turpentine substitute; those used with water-based paint can be washed in water and a little detergent.

Acrylic Paints: Probably the most versatile, these water-based paints come in a wide range of bright colours, dry very fast to give a rich glossy finish, and unlike gloss paints, you don't have to prepare the surface first with primer or undercoat. They are fully waterproof and are suitable for both indoors and out.

Ceramic Paints: These are solvent-based paints designed for use on clay and pottery, though they are also suitable for glass, metal and wood. They come in a wide range of colours and give a glossy, opaque finish. Ideally, they should be used on items which receive little wear. Ceramic paints require at least 24 hours to dry, after which you can apply a coat of ceramic varnish to help protect the design.

Glass Paints: Also principally solvent-based that, when used on glass give a stained-glass effect. They can also be used on china and pottery to give a translucent finish. Glass paints are rather thick, sticky and difficult to apply, so they need some practice to apply correctly. They take at least 24 hours to dry (in a relatively dust-free environment). The item to be decorated must also be totally free from grease or dust before you begin which may mean washing well in warm soapy water then wiping with a cloth soaked in methylated spirits or petroleum

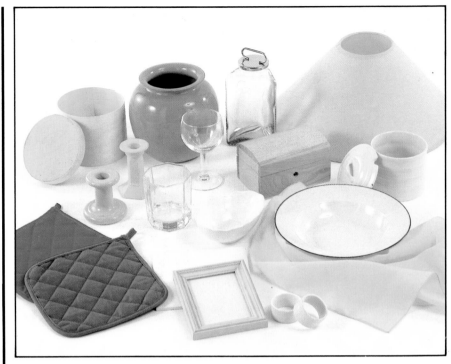

Plain items such as these are ideal for decorating, and there are paints available to suit any surface, be it wood, glass, ceramic, fabric or plastic.

essence. A second coat of paint may be necessary after the first has dried to achieve a strong enough colour. Water-based glass paints are also available.

Fabric Paints: There are various kinds available. Most need to be used on unbleached white or naturally coloured fabrics for the colours to remain true. However, there are paints available for use on dark fabrics; these tend to sit on top of the fabric as opposed to being absorbed by it.

Fabric paints must be 'fixed' so that the colours do not run when the fabric is washed. Manufacturers will recommend the method best suited for fixing their products; a common method is by heat.

Silk-paints: These can be used on wool as well as silk. In this book they have been used in conjunction with gutta, a gum-like substance which outlines each colour like lead outlines stained glass.

Varnishes: A coat of varnish will protect your paintwork. Polyurethane varnish is ideal for wood and comes in a matt or gloss finish. Ceramic varnish is specially designed for china or pottery. Other varnishes include crackle varnish (see page 77) which gives a crazed, 'antique' effect.

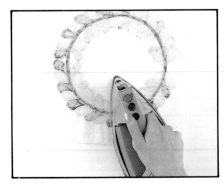

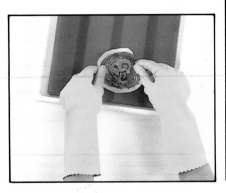

Far left: Most fabric paints can be fixed by ironing on the reverse of the design.

Centre: Some silk paints must be fixed in a special solution for five minutes, 48 hours after you have finished your design.

Left: Ceramic paints are not very hard wearing so protect your design with a coat of ceramic varnish once the paints are dry.

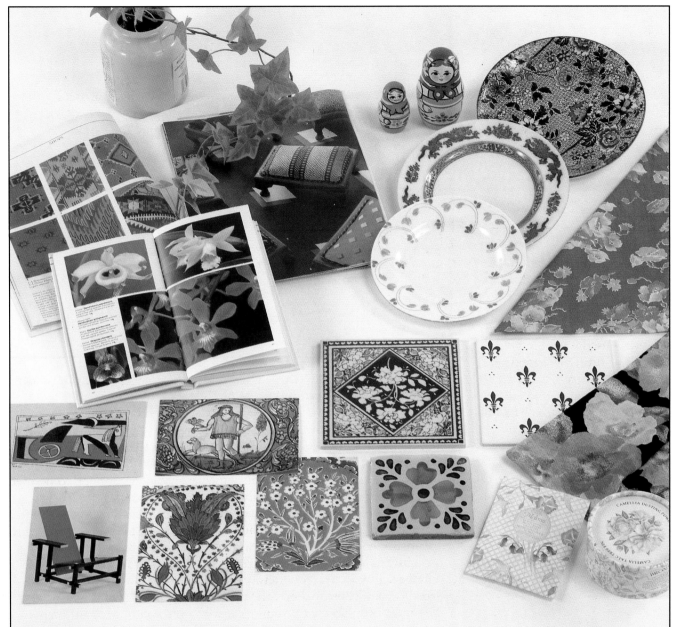

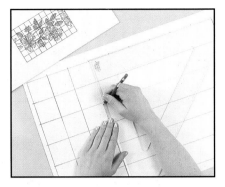

Above: If you wish to enlarge a design, first draw a grid of squares over it. Now, using a set-square, draw an enlarged grid on a piece of plain white paper.

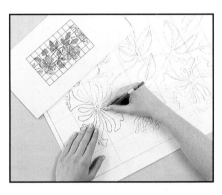

Above: Copy the design on to the new grid, square by square, paying particular attention to where the design lines enter and leave the squares.

Left: Old china plates, ceramic tiles, books, magazines, postcards, fabrics and attractive packaging can all prove a source of inspiration for designs.

To begin with, you will probably want to follow the designs featured in this book. But as you become more confident and adventurous with your painting, you will no doubt start to look around for other ideas to copy or adapt. Many people believe that copying is cheating, but even the greatest designers of this and past ages would admit that they seek inspiration for their work from a wide range of sources. The photograph above shows you some of the many items to which you can turn for inspiration. Museums and art galleries can also provide an endless source of ideas.

Once you have worked out your design or found one to copy, you may find that it is too small (or too large) for your purposes. The easiest way to draw it to the size you need is to use a method known as squaring up. This is the same method you will need to employ when using the templates in this book. First of all, trace your design on to a grid, using either graph paper or a grid drawn by hand; squares of 10mm (½in) should be suitable for this stage. Now draw a second grid on to tracing paper, making the squares either larger or smaller than the original grid, depending on what size you want your final design; for example, if the image is to be twice the size, make each square twice as large. Finally, copy the design, one square at a time, on to the new grid, being careful to note where the design enters and leaves each of the squares.

If you have traced or squared up an image and you wish to transfer it to the object to be decorated, such as a piece of fabric or a wooden box or frame, you can follow this simple procedure: turn your trace over and go over the outline on the reverse side with a soft pencil; now position the trace reverse side down on to the object and go over the outline once more. Alternatively, you can place a piece of carbon copy paper face down on to the surface of the object; place the design on top and draw around the outline.

The materials for stencilling are many and varied. Pictured below is a selection of the paints, brushes and tools you will need. Some projects only require one brush, one pot of stencil paint, a knife and a small sheet of acetate, so the cost need not be daunting.

There is a wide variety of paints suitable. Quick drying stencil paints are ideal. They are water-based for easy cleaning, and come in a wide range of colours. Stencil crayons are large oil-based crayons that produce a soft effect when applied with a stencil brush. They are very easy for a beginner as there is no danger of runny paint leaking under the stencil. You can also use a number of water-based fabric paints. These are either of a jelly or fairly liquid consistency and are easy to apply with a stencil brush or sponge.

Other suitable paints include ordinary household emulsion paints, cellulose car spray paints and household spray paints. Acrylic paints are also good for flexible surfaces such as roller blinds or shower curtains.

The stencil itself can be made from anything which masks out an area of background. Although you can employ doilies, lace or even masking tape to create a stencil effect, the most common stencil is one which is cut from cardboard or acetete.

Stencil card is brown, flexible, oiled cardboard that is very easy to cut, but opaque. This means you have to transfer the design directly on to it and that you cannot see through it to match up the design when stencilling. It does not last very long with water-based paints and is becoming harder to obtain as it is being superseded with plastic materials such as Mylar. This, and other types of plastic film sold for use in drawing offices, is very economical if you are going to do a lot of stencil cutting. A medium thickness film is best, and you can even buy Mylar ready printed with guidelines, especially for stencilling. All of these plastic films are transparent, which means you can lay the film

Here are some of the many, tools and materials you can use for stencilling, including craft knives, brushes, plastic film, masking tape and sponges.

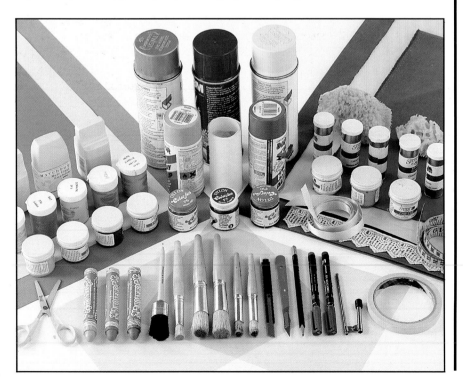

over a design and cut straight through. You can also see through while stencilling, which is a great help when lining up a set of stencils.

To cut the stencil you will need a good craft knife with a replaceable blade. A rubberized self-healing cutting mat is the perfect base for cutting on, otherwise a sheet of thick cardboard makes a good substitute. To mark the film or card, you will need a thin waterproof felt-tipped pen. Low-tack masking tape is also essential for attaching the stencil to the wall or object without damaging the surface.

Remember, you will require a separate stencil for each colour being used so trace that part of the design which is to be painted in the first colour then trace the remainder of the design with a dotted line. Make a second and if necessary third stencil for subsequent colours. Now simply cut out the continuous line on each of the stencils using a stencil knife. Cut towards you, turning the stencil rather than the knife. On a repeating stencil pattern, such as a border, always draw a small part of the pattern either side of the main design so that you can use this for repositioning the stencil each time you finish a section.

STENCILLING TECHNIQUES

Brush stencilling on hard surfaces is the traditional method of stencilling, producing the familiar speckled texture. Use a good quality, flat, or slightly domed, stencil brush. Pour a little paint into an old saucer and dip just the tips of the bristles into it. Dab off some of the excess paint on to a piece of kitchen paper and you are ready to stencil. Tape the design in place and, holding the brush upright, dab on the paint with a gentle 'bouncing' movement. Make sure the edge of the stencil area is coloured to maintain the outline of each shape, but you can leave the centre of each area very pale. Don't put on a thick layer of paint but build up the colours in certain areas to look like shadows, giving your design a three-dimensional quality. Check your progress by lifting the stencil occasionally and you'll find it is surprising how little paint you need to hold the design.

Brush stencilling on fabric is very similar to working on hard surfaces but you must make sure your fabric is washed, ironed and taped or pinned out flat on an absorbent paper-covered work surface. Natural fabrics are best. Tape the stencil very lightly to the fabric and work with the minimum amount of paint on the stencil brush to avoid it spreading under the stencil. When using the metallic finishes, dip the brush into the lustre paint and wipe off the excess. Tip a tiny amount of the metallic powder on to a piece of velvet and spread it out evenly over the fibres. Dab the brush into this, shake off any excess and then stencil. Don't mix the powder directly with the lustre to form a paste.

Oil-based stencil crayons also need brushes to stencil the colour. First break the clear seal on the tip of the crayon by rubbing it on to rough paper. Then scribble some of the colour on to an uncut corner of the stencil and rub the stencil brush into this to collect the colour. Rest the bristles lightly on the stencil and use a circular movement to spread the colour from the edges of the design into the centre. You can blend the colour very easily before the crayon sets but use a clean brush for each colour to avoid a muddy finish. Leave the design to set for a few hours to avoid any smudging.

Sponge stencilling is an ideal method of stencilling on emulsion painted walls when using a large open design. The sponge is simple to

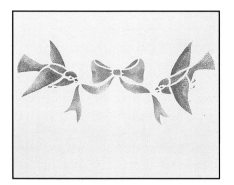

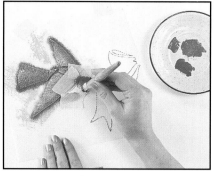

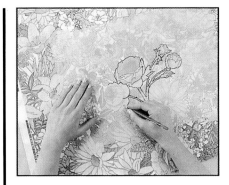

Choice of colour plays an important part in stencilling – here, a change of colour scheme has converted two bluebirds into Christmas robins!

To change the colour scheme of an existing stencil, don't bother making a new one – simply mask off the unwanted areas of the old stencil.

Choose a design motif from a piece of fabric, wallpaper, giftwrap, a book or a magazine, then carefully trace the shape on to tracing paper.

Now convert the motif into a stencil by redrawing it with 'bridges', so that whole areas of the design are enclosed within a continuous line.

use, especially for a beginner, and the instant mottled texture is very easy to control. Always dip the sponge in water and squeeze out all the moisture before you start, to make the sponge soft and pliable. Pour a little paint into a saucer and dip the sponge into it. Dab off the excess on to spare paper and then stencil with a very light dabbing motion.

It is very important to clean the surface of your stencils from time to time, otherwise the build up of paint will eventually close up small holes in the design and make the edges ragged. Use the appropriate solvent, wiping the paint off on to waste paper. When you want to reverse the stencil, you must clean the surface thoroughly to avoid transferring paint on to the design surface in the wrong place.

—— *VARIATIONS ON A THEME* ——

When you have tried some of the stencils by the methods described in this book, try out other variations for yourself. You will find these experiments are a worthwhile way of making full use of the stencils you have cut.

Colour makes a great deal of difference to the feel of the design as you can see here. The bird and bow design above was originally designed for the Lloyd Loom chair (see page 33) and was sprayed in pale peach and white. However, it looks delightful as a Christmas motif if you mask off the birds' breasts so that you can change them into robins. Stencil the main part of the body in light brown and the breast in red. The bow looks rich and satiny stencilled in green, with subtle

darker shaded areas making it look almost real. Use this motif at any size to decorate special table linen for a Christmas party, a border around the room or even as a central design on a chimney breast. You can also alter the relative positions of your stencils. Look at the corner design for the photo frame on page 47. It's interesting how different this can look placed back to back to make a border design or close together in pairs to make an oblong pattern. Try out some of these ideas on large sheets of paper to get the most from your designs.

You may also wish to make your own designs, taking inspiration from a favourite curtain fabric, picture or wallpaper. You will first need to trace off parts of the design, choosing a single motif such as a sprig of flowers, or a decorative bird. Trace the design carefully and enlarge or reduce the size, as necessary, depending on the project. Always keep your initial designs and tracings as they may come in useful for future projects in different colours or applications. To translate your design into something that can be cut out and stencilled, you need to simplify and adapt the shapes so that you can add 'bridges' to the design. Bridges are small spaces between parts of the design that give the characteristic look of stencilling and add strength to the material out of which you are cutting the design. A long curving stem, for instance, should have several bridges across it to stop the material moving as you stencil - any movement would allow paint to creep underneath.

Try playing around with your designs to create different effects. Placed back to back, this corner design from page 47 makes a very pretty border.

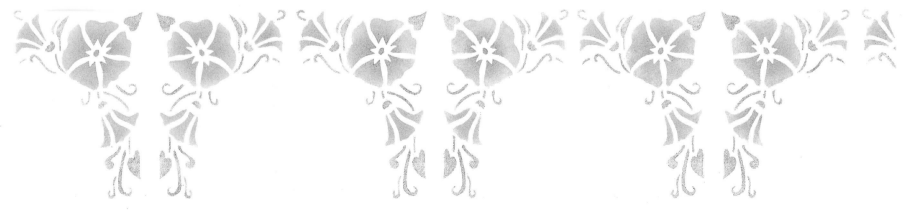

STENCILLING DESIGNS

GARDEN ROOM

Stencilling is ideal for decorating a wide variety of household items including lamps, picture frames, fabrics and furniture. It is also an excellent method of decorating rooms, particularly those with uneven walls or odd-shapes, and for drawing attention to architectural features such as arches and exposed beams, especially in old houses. Modern houses take kindly to stencilling too by giving some much needed character to otherwise boxlike rooms. The first part of this chapter concentrates on designs for rooms, with stunning ideas for a sitting room, hall, study, kitchen, bathroom and bedroom. Following these is a selection of smaller projects for those with less time to spare.

This lovely light sitting room has been given an outdoor feel with a trellis design stencilled in panels just below the coving. The wisteria design is stencilled in a random fashion over the trellis so that you can 'grow' as many flowers as you like. On page 15 there's one stencil design for the large blossom and one for the smaller spray with accompanying leaves and buds. By using these and turning the stencils over you can create an infinite variety of groups of flowers.

The accessories such as the curtains, lamp and cushions have all been stencilled to complement the trellis design and make the room feel part of one whole theme, using colours and styles to bring it all together.

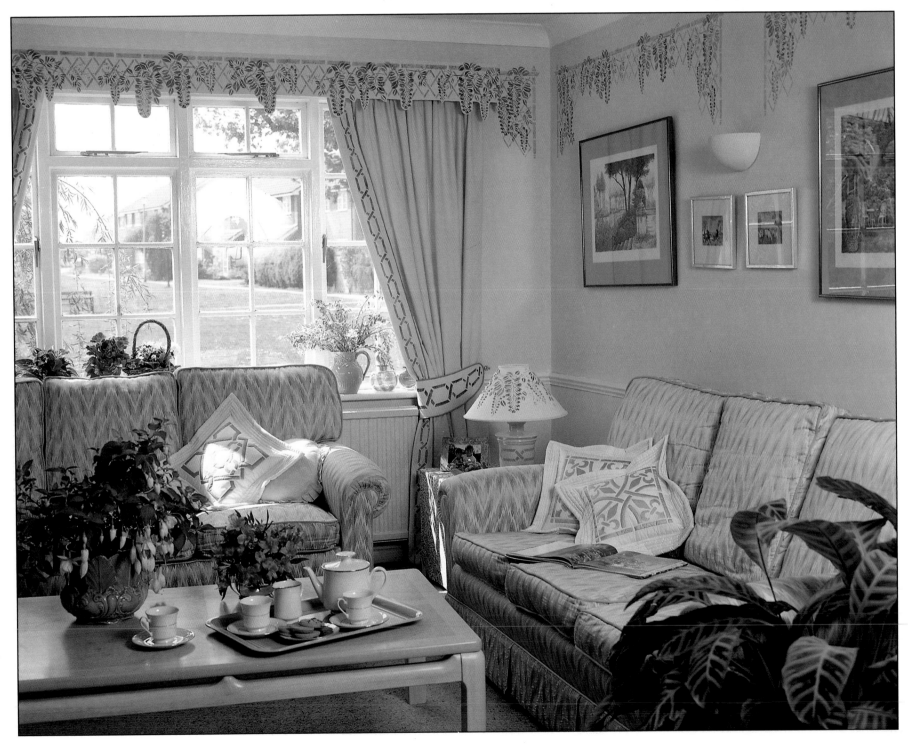

WISTERIA TRELLIS BORDER

 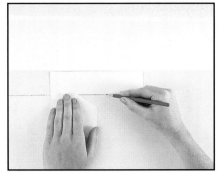 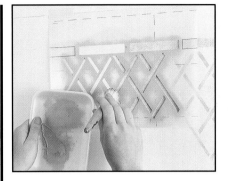 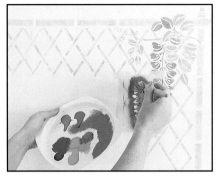

First paint the walls in a cool minty green. The subtle texture of ragging looks very effective with stencilling. To achieve this effect, pour a little creamy yellow emulsion paint into an old dish and dip a scrunched up square of rag into it. Blot the excess on to spare paper and then dab the rag on to the wall in a random fashion to create an open texture.

Measure a little way down from the coving or ceiling and cut a cardboard template to mark this distance around the room as shown. This will help you align the top of the stencil. Enlarge the stencil designs on pages 15-16 using the squaring up method. Next cut the stencils: two end trellis pieces and one joining piece; one large and one small wisteria stencil; and one leaf stencil.

Start by taping the two end trellis stencils on to the wall and then mark where the joining piece will go, adjusting the ends to fit the design exactly. Mark lightly in pencil. Begin stencilling at one end using quick-drying stencil paints. Stencil very lightly in pale grey and accentuate the colour where the struts go under each other to look like a shadow and give a 3-D effect.

Position the wisteria and leaf stencils randomly to make large and small bunches. Start at a corner and work towards the trellis centre, waiting for the paint to dry before you overlap the next stencil. Mix the colours so that you get a varied range from blue to mauve in the flowers and several shades of green leaves. Clean the stencil with a damp cloth to use the reverse side.

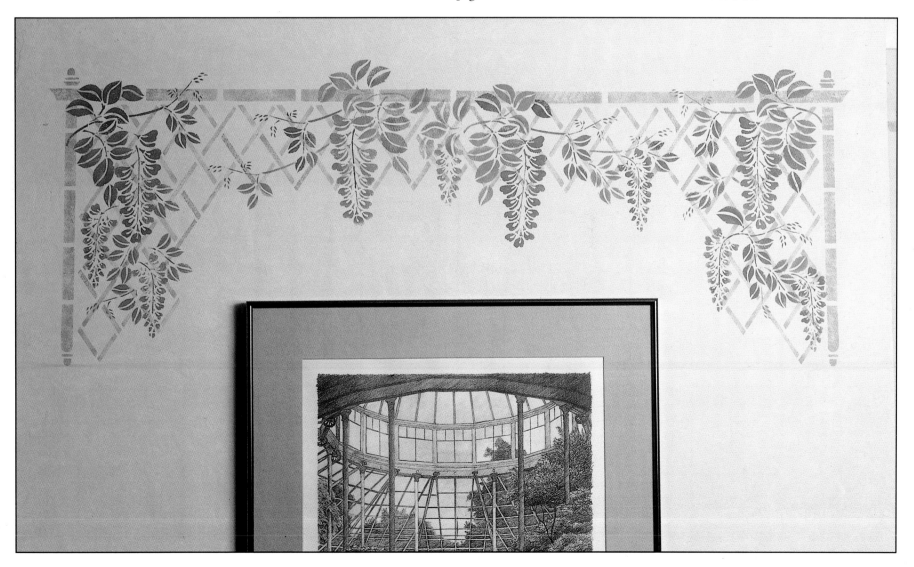

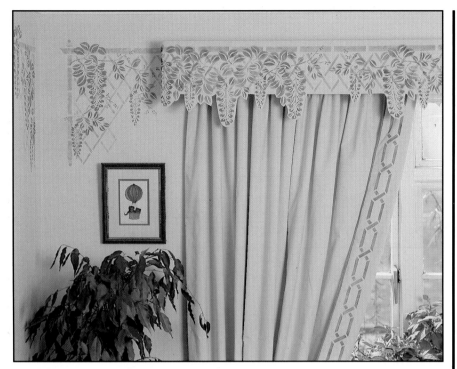

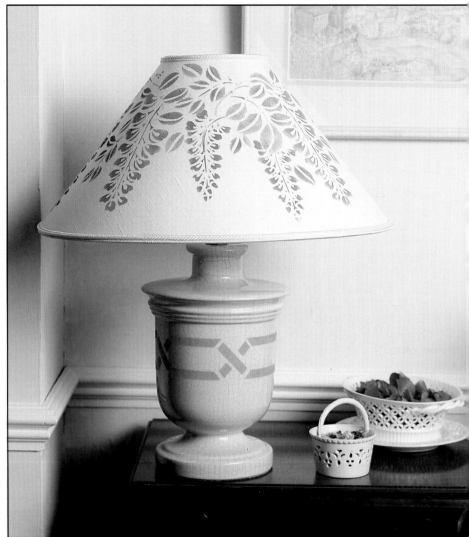

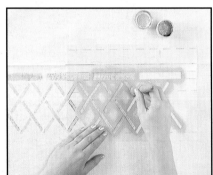

The pelmet is made of stiffened calico to match the curtain fabric. You need a piece of calico about 56cm (22in) wide, and 60cm (24in) longer than your window. Fold the fabric in half along the length and stencil the joining trellis motif 2cm (³/₄in) down from the fold. Use grey fabric paint, dabbing it on lightly with a stencil brush for a speckled texture.

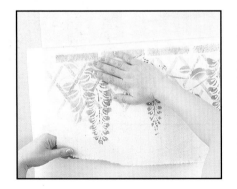

Stencil the flowers and leaves, keeping below the fold line. Leave to dry and then iron to fix the fabric paint. Cut a piece of self-adhesive pelmet stiffening about 5cm (2in) shorter than the stencilled fabric. Peel off the backing paper and press the fabric on to the stiffening, making the top edge of the stiffening run along the fold. Smooth out any air bubbles.

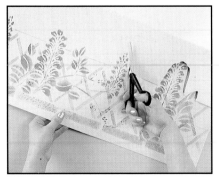

Peel the backing paper off the reverse side and press the fabric on to the back. Turn in the ends to neaten. Draw a line just below the trellis and then cut along this and around the flowers. Fix a strip of Velcro along the reverse side of the top edge and attach the matching half of the Velcro to a pelmet rail positioned so that the trellis on the pelmet lines up with the wall border. Press in place.

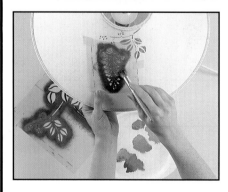

Use the flower and leaf stencils to decorate a plain coolie lampshade to go with your wisteria trellis room. Start with a spray of leaves and then add the flower spray. Work around the shade to make a balanced pattern. Use fabric paints and stencil very lightly so that the light will shine through and bring out the colours rather than making a dark silhouette.

Decorate the pottery lamp base too using the curtain border motif. Tape the stencil carefully around the lamp so that it does not slip. Stencil lightly with peach coloured ceramic paint. Leave to dry, then shade with a light coat of mauve paint. Adjust the border stencil so that it meets up around the lamp without leaving a gap. Leave to dry for 24 hours, then varnish to complete.

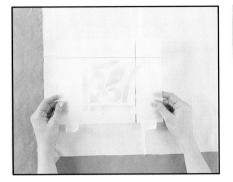

These cream silk cushions are stencilled in metallic fabric paints and quilted to make sumptuous accessories. Draw up and cut out the quarter design stencils from page 15. Mark the horizontal and vertical lines on the stencil and match these up with central pressed folds on a 48cm (19in) square of cream Honan silk. Tape the silk in place on a worktop protected with paper.

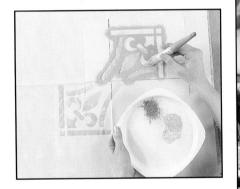

Tape the stencil in position and dip the brush into pearl, gold or silver lustre. Wipe off the excess and dip into gold powder. Shake off any excess and stencil with a light dabbing stroke. Move the stencil around the silk, lining up the marks with the creases·in the silk each time to complete the pattern. Leave the paint to dry for about 24 hours, then set with a hot iron.

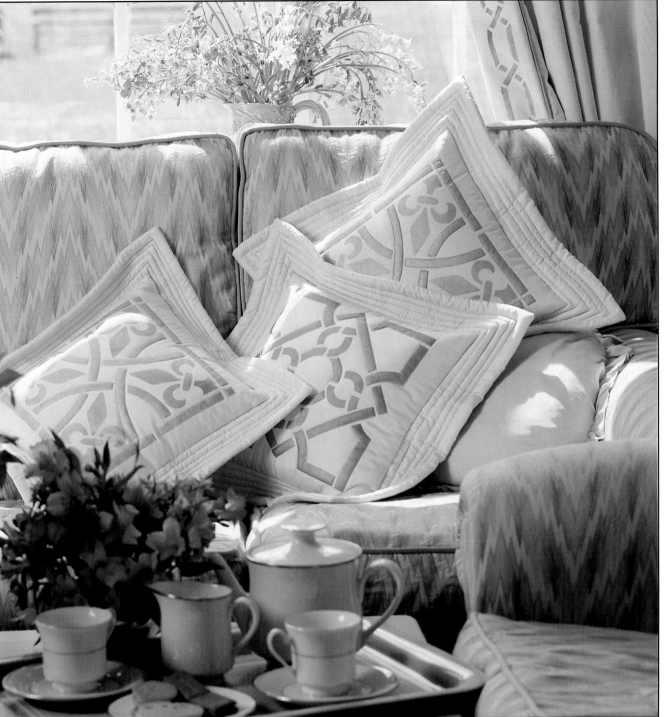

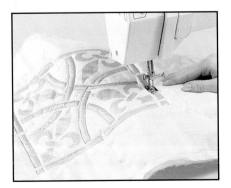

Cut a piece of polyester wadding the same size as the silk. Tack the layers together with several rows of stitching to hold securely in place. Using a sewing machine, stitch around some or all of the stencilled motifs to quilt them. Pull all the threads to the back, tie and cut off. Cut two backing pieces of silk 25cm x 48cm (10in x 19in). Turn under one long edge on each piece.

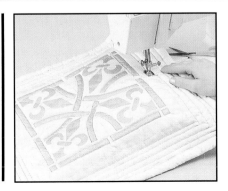

With right sides together and raw edges matching, pin and stitch the two backing pieces to the cushion front. Trim the wadding from the 1.5cm (⅝in) seam allowance and turn the cover right side out. Press lightly. Stitch parallel rows around the cover through all the layers to make a 6cm (2½in) wide border. Insert a 30cm (12in) cushion pad and hand stitch the opening.

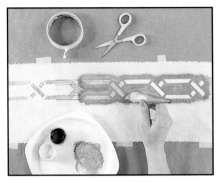

Trace and cut out the border stencil opposite to make a decorative padded edging for plain calico curtains. Cut a piece of calico 25cm (10in) wide and the length of each curtain. Tape the fabric flat on the work surface and lightly stencil in mauve to match the wisteria stencil. Place the stencil to print 4.5cm (1¾in) from one raw edge of the fabric.

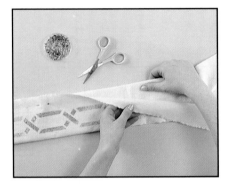

Leave the stencilled fabric to dry and then fix the paint with a hot iron. Fold the fabric in half lengthwise and lay a double thickness of curtain interlining or bump between the layers of calico. This should be the same width as the folded calico. Pin the top layer and the interlining together along the raw edge to hold in place.

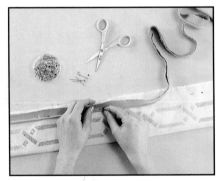

Make up some piping using narrow cord and a bias strip of toning chintz or repp. Pin and stitch this to the top layer of calico and the interlining. Pin this, right sides together, along the leading edge of your curtain and stitch close to the piping cord. Fold the free edge of the border to the reverse side of the curtain, turn in the raw edge and slipstitch to finish.

Enlarge and cut out the tie-back stencil, marking the outline of the shape on the acetate. Mark a line halfway across the calico and stencil as for the curtain border, using fabric paints. Leave to dry and fix with a hot iron. Cut out a piece of pelmet stiffening to the tie-back shape, remove the backing and press on to the back of the stencilled calico.

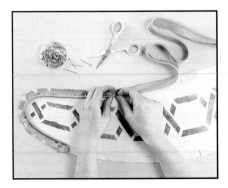

Trim the excess calico leaving 2cm (¾in) all around. Pin on covered piping cord, matching raw edges and clipping the curves. Stitch around the edge, close to the cord. Remove the other backing sheet and fold the seam allowance to the back. Cut another calico tie-back, press under the raw edge and slipstitch to back of the stencilled tie-back. Stitch a small ring to each end.

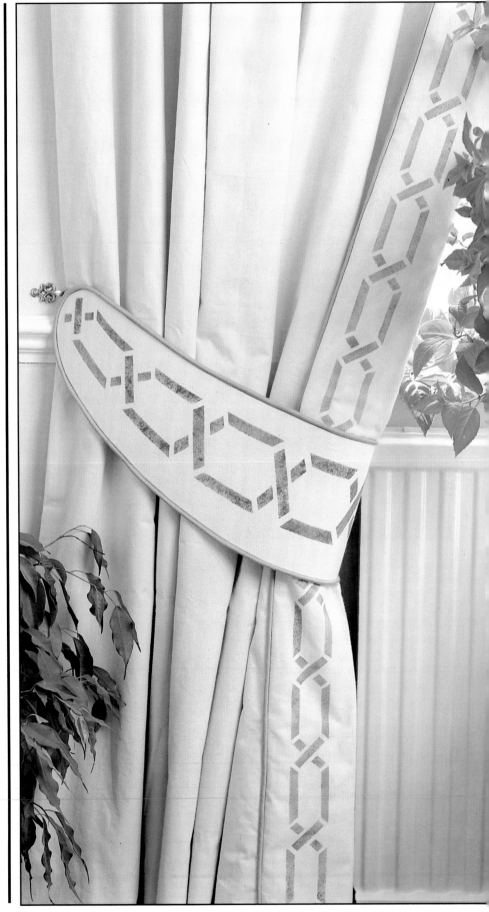

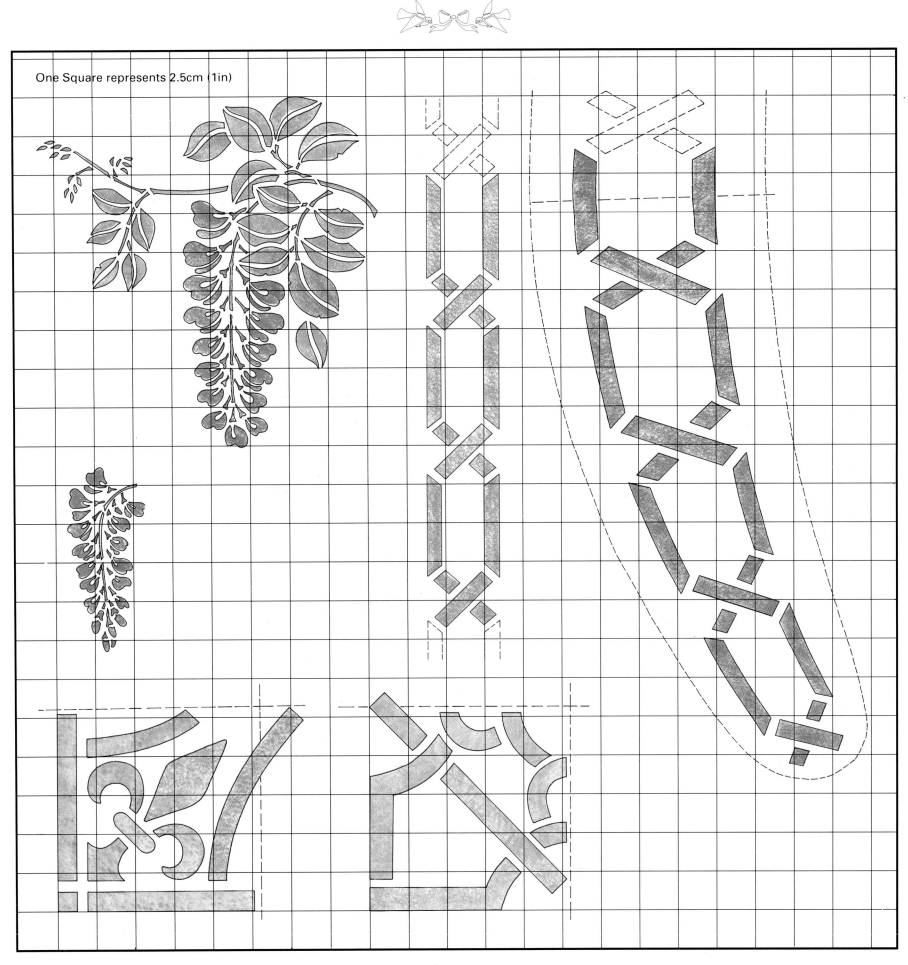

One Square represents 2.5cm (1in)

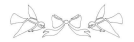

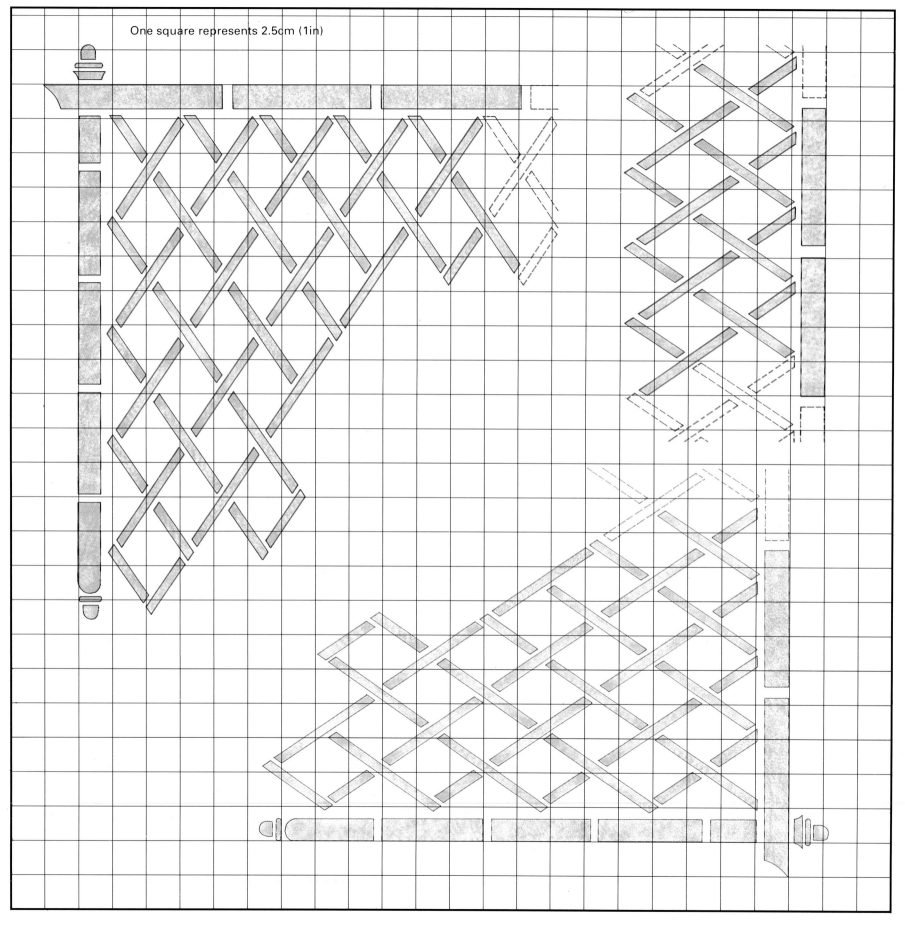

One square represents 2.5cm (1in)

The pretty Dutch-style border tiles were the inspiration for the fresh floral stencils that enliven an otherwise rather stark kitchen. The simple kitchen units have a sprayed-on design featuring the tulip-shaped flower heads arranged formally in an urn. The design is deliberately symmetrical so that it is adaptable for different widths of door unit and does not catch and hold the eye too much all over the room. Even the fridge and dishwasher have been stencilled to match.

If your kitchen cupboards have plain wooden doors, this pattern is also suitable, provided you use paler or darker shades to the wood to make the design stand out. Rub varnished surface lightly with steel wool, then use car sprays or quick-drying stencil paints. The flower border is very stylized and is a pattern that can be used successfully either around windows and door frames or singly on a shelf unit. It can even be used over pictures to act as a decorative hanger. It is also an easy design to curve around the table edge or to position in a circular central motif as shown on the table top and chair seats on page 20. You can use a design like this to make the co-ordinated kitchen you've always dreamed of.

Start by enlarging and cutting out the whole stencil for the door units (see page 21). You will notice that the left hand door unit in the picture below is considerably narrower than the one on the right. The stencil design will fit comfortably in the narrower space, without looking squashed, if you omit stencilling the outer two petals of the most extreme left and right blooms, thus turning them into buds. To do this, lay strips of masking tape over the appropriate areas to block them out completely. Carefully trim any excess tape covering the adjoining areas, using a sharp craft knife. You can peel the masking tape off easily when you have stencilled the narrow door.

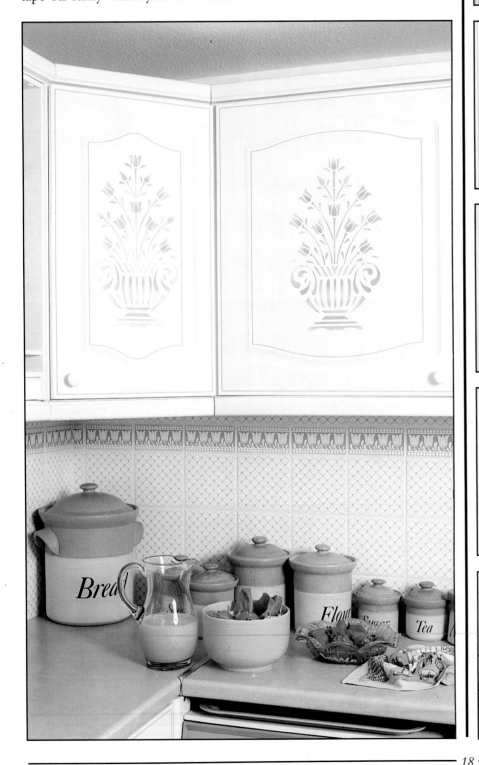

Clean the doors thoroughly to remove dirt and all traces of grease before stencilling. Mark the centre lines horizontally and vertically on the acetate. Mark these lines again near the outer edge of each door, using a chinagraph pencil and a set-square and ruler.

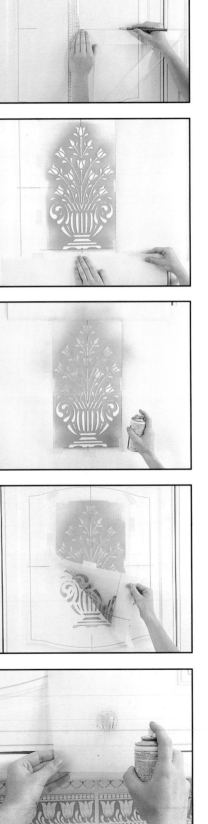

Very lightly cover the back of the stencil sheet with spray glue. This will make it adhere to the vertical surfaces and prevent the spray paint from creeping underneath. Tape the stencil in place, lining up the register marks accurately. Tape sheets of waste paper around the edge of the design to protect the area from overspray.

Use cellulose car spray paints to colour the stencil, spraying gently back and forth from about 30cm (12in) away. Shake the can well before spraying and aim for a light even coating so that the paint does not run. Return after a few moments and add short bursts of spray in certain areas, such as the base of each flower, to enliven the design but don't fill in the stencil too much.

Leave to dry for a few moments and then remove the paper mask to use again. Gently lift off the stencil, checking that the paint has not run underneath. If it has, quickly take a small rag or cotton bud dipped in paint thinners and very carefully wipe away the mistake. Leave stencil overnight to dry hard then clean off the register marks with liquid detergent.

To stencil the handles, cut a small flower in the centre of a 30cm (12in) square sheet of acetate. Spray the back with glue and press in place on handle. Give two light bursts of colour and carefully remove the stencil. Leave to dry hard. These stencils will withstand ordinary washing with detergents but not abrasives. It is possible to remove them with thinners.

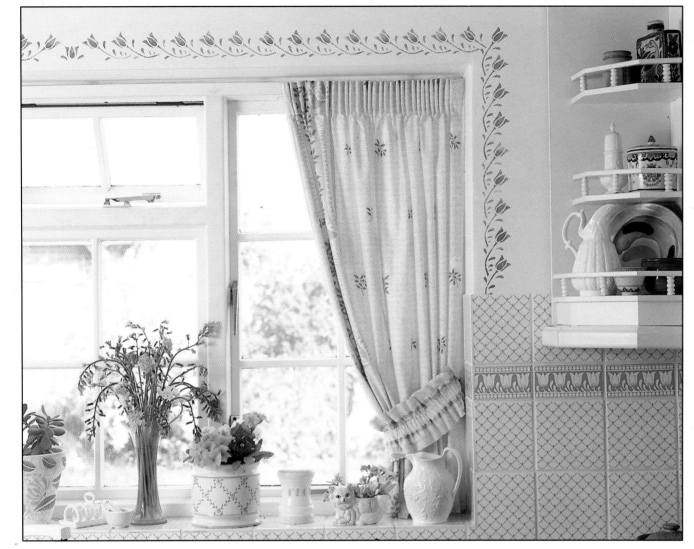

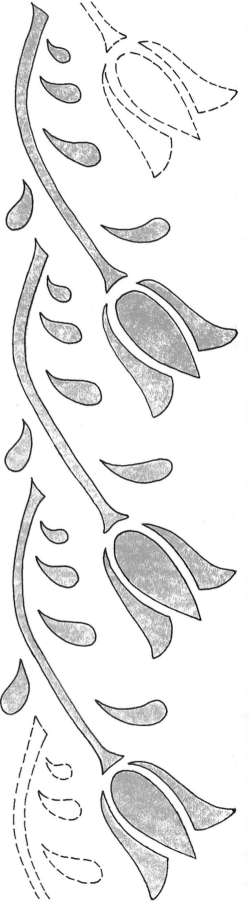

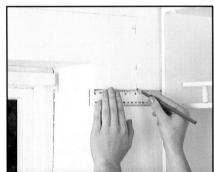

Trace and cut out the tulip border stencil opposite, drawing in lines top and bottom to keep it level. Try it around the window and then mark the wall with a chinagraph pencil to position the design accurately each time. Mark the centre point along the top of the window, where the design will change direction.

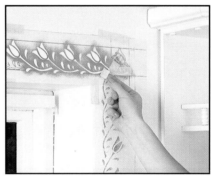

Once again, start at the corner and work across the top of the window. Use masking tape where the design overlaps so that you block out the area already stencilled. Work towards the centre point and stop just before it. Clean the stencil, turn it over and stencil the other half of the window. Lastly, put a single flower head at the centre point to complete.

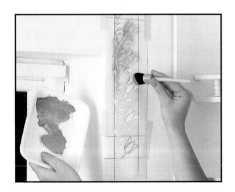

Work out how the design will link best at the corner, perhaps using a trial stencil on scrap paper. Start stencilling at the corner and work down towards the sill. Use quick-drying stencil paint in a blue-grey and stencil quite lightly to give a soft, grainy texture. Wipe the acetate occasionally to prevent clogging.

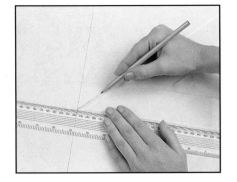

These table and chairs have been ragged in soft blue eggshell paints to go with the kitchen and then stencilled with the tulip design. To decorate the table, find the centre of the table and accurately draw four intersecting pencil lines. Trace off one tulip motif from page 19 and cut out in acetate with a sharp craft knife.

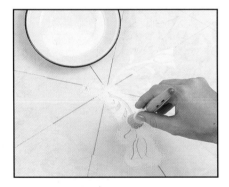

Mark intersecting registration lines on the stencil, making one of the lines run through the centre of the flower. Tape the acetate on to the table, lining up the registration and pencil marks carefully. Stencil with a large brush in white eggshell paint. Apply two light coats before removing the stencil, allowing the paint to become touch-dry between coats to avoid smudging.

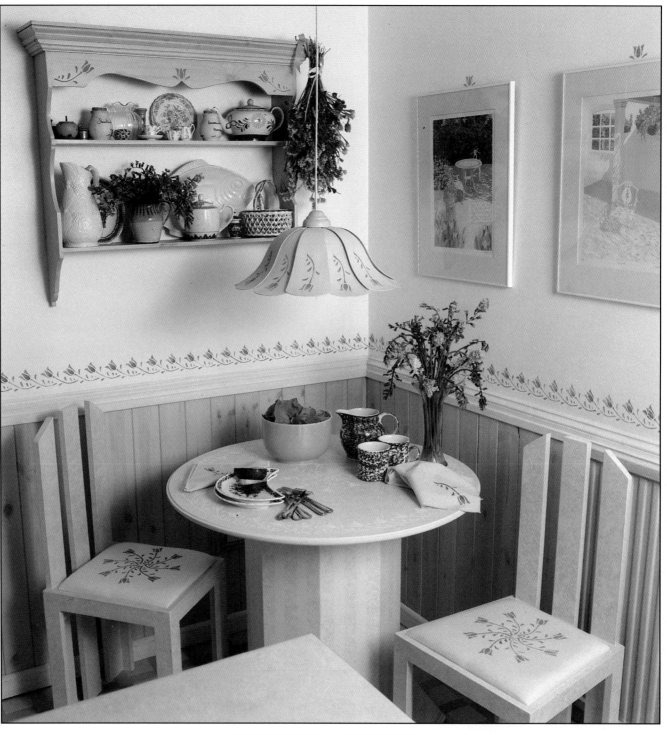

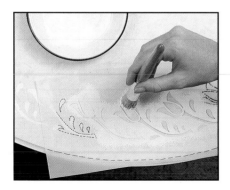

Draw the curve of the table edge on to a large sheet of tracing paper. Use the border stencil design to draw out a curved version to fit your table exactly. Simply move the pattern to line up each motif with the curved line and then trace it off. You will need about three motifs. Cut out the stencil and then paint as for the table centre.

The chairs have drop-in seats so it is easy to stencil fabric and staple it in place. Use heavy, white cotton fabric cut 10cm (4in) larger than the seat. Stencil as for the table centre using pale blue fabric paint. Fix with a hot iron when dry. Pull the fabric taut over the seat and staple the corners to the underside first, then staple the sides, working from the middle outwards.

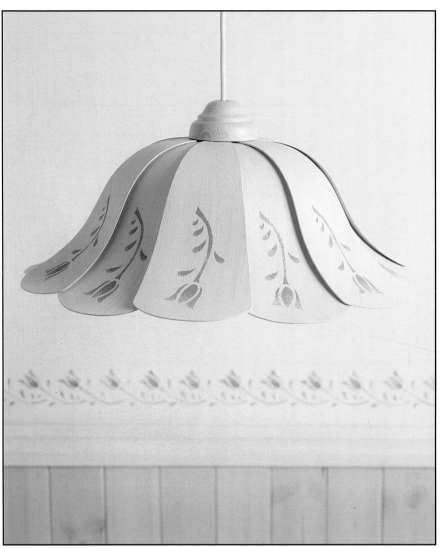

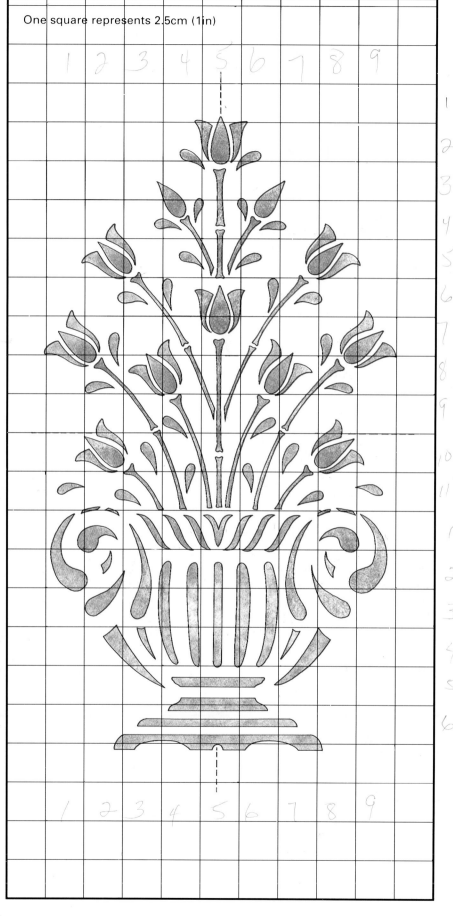

One square represents 2.5cm (1in)

S tencil a pretty pine lampshade to hang over the corner table and complete the setting. Sand the wood smooth and paint with two or three coats of pale blue satin varnish. Use a single flower motif and trim the acetate to fit one section. Place the stencil centrally and draw in the outline of the section to align the stencil accurately each time.

Tape the stencil on one section and stencil all over with quick-drying stencil paint in pale blue. Use a clean brush and lightly shade the base of the flower and leaves with a darker blue-grey paint. Leave to dry and give the whole shade a coat of clear matt varnish to complete it.

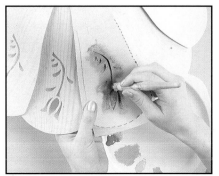

This hall started out as a rather bleak modern passageway but with the clever use of colour and stencilling it has become a delightful entrance to welcome you into the rest of the house.

The border design was drawn from Italian decorative stone carvings from the 16th century and the 'wallpaper' design is adapted from a Florentine Renaissance motif. Try out the border design in a single colour as well as the two-colour version used here – it's interesting how different it can look and, if you prefer it, you will then only need to cut one stencil.

The beauty of stencilling 'wallpaper' is that you can position the motifs exactly where you want them – no half patterns as you reach a corner – you just move the pattern along slightly and it all fits in. Similarly, uneven walls and un-square corners can also be conquered.

The semi-circular table is stencilled to match the wall border after being given a marbled paint finish in grey, beige and white. The wall border pattern has been curved to fit the table and also to go around the top of the mirror which helps to lighten and enlarge the area. There are full instructions on page 24 on how to adapt a straight border to fit around any curve so that you can stencil wherever you choose.

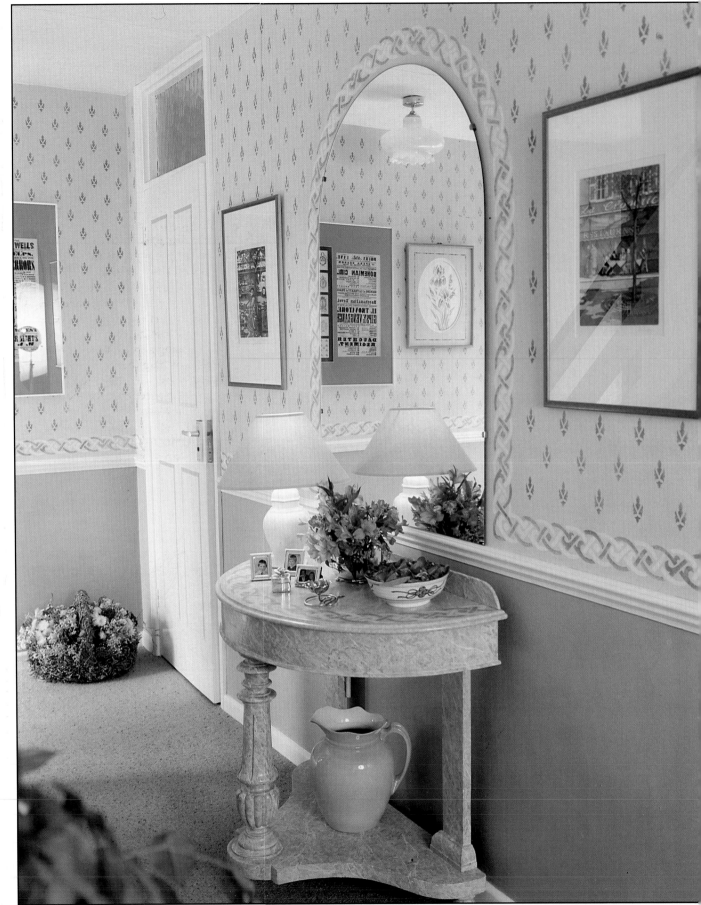

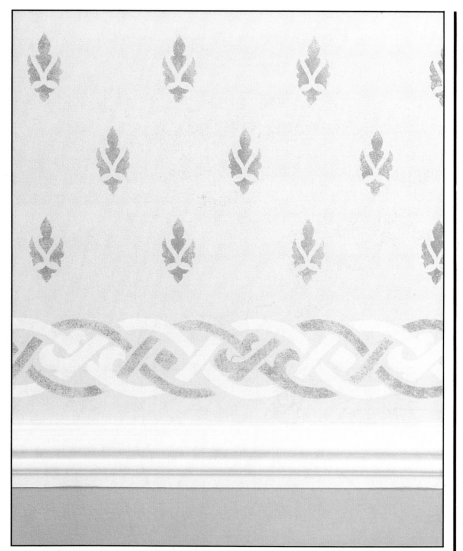

Start near the top of the wall and work one row of motifs vertically down the plumb-line. Make pencil marks first so that the design starts about 5cm (2in) from the ceiling and leaves a 11.5cm (4½in) space above the dado rail for the border. Mix up some grey quick-drying stencil paint and brush stencil lightly to give a soft, grainy texture.

When using a small, two-motif stencil, overlap the lower motif you have stencilled with the top one on the acetate sheet to space the first row accurately. The small stencil is useful in tight corners and close to door frames to prevent bending the acetate too much.

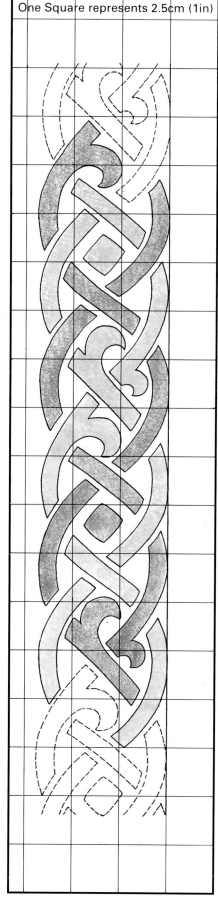

One Square represents 2.5cm (1in)

Trace off the Florentine motif opposite. Draw out the pattern carefully, spacing the motifs evenly about 9cm (3½in) apart vertically and 7.5cm (3in) apart horizontally. You will need two motifs minimum for small areas but you will greatly speed up the stencilling if you cut a sheet with six or eight motifs. Also draw on vertical guidelines and dotted motif outlines.

Find the centre of the wall and use a plumb-line to mark a vertical pencil line down to the dado rail. Join up the pencil marks with a long ruler and use this line to begin stencilling.

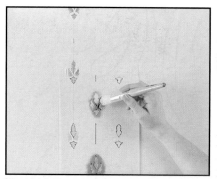

Work the next vertical row of motifs matching up the dotted areas with the first row of stencilling. Continue all over the wall. Adjust the space between rows very slightly to accommodate awkward corners. Stencil within 13cm (5in) of the mirror edge. If there are large gaps near the curved area, leave them and add another motif later when the border is complete.

FLORENTINE BORDER

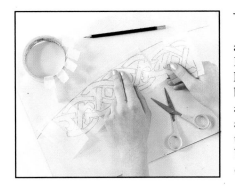

You will need to curve the stencil border design to fit exactly around a curved table top or mirror. First, trace out your curve on to a large sheet of paper. Size up the border design from page 23, trace it and cut slits alternately into the top and bottom edges of the design so that it will bend easily. Tape the border design in place over your curved line.

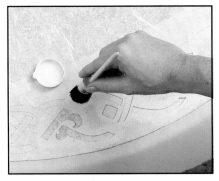

Trace the adapted design, extending and curving the lines where needed. Now cut one stencil for each colour. Mark on dotted register lines and also the curved line to follow the table edge, using a waterproof felt-tipped pen. Stencil in white quick-drying stencil paint, dabbing with a large brush to make a soft, grainy texture over the marbling. Leave to dry before removing the stencil.

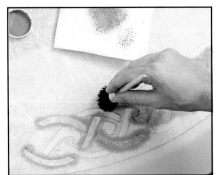

Tape the other stencil sheet in position and stencil with an almost dry brush in blue-grey paint. Dab most of the paint on to kitchen paper before you work on the stencil to achieve a subtle mottled finish that will blend well with the marbling on the table. Varnish to protect when the stencil is dry.

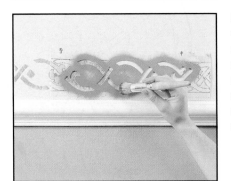

Stencil the straight border on the wall just above the dado rail. Cut the edge of the stencil so that it will run along the dado rail to make measuring unnecessary and stencilling quicker. Use the same stencil paints as for the table top and stencil quite lightly

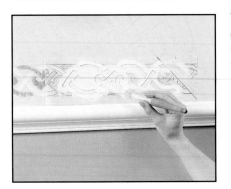

When you reach a corner, at the side of the mirror, lay a piece of masking tape across the stencil at a 45° angle, to mitre the corner. Stencil up to the tape on both stencils. Stencil the curve around the arched top of the mirror first, then work the straight design down towards the dado rail. Mitre the corner again to match up with the rest of the border.

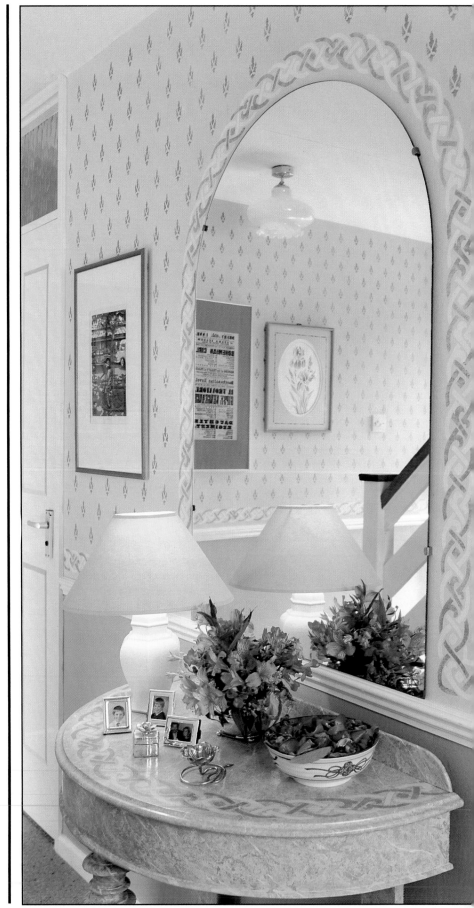

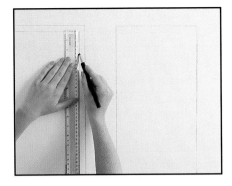

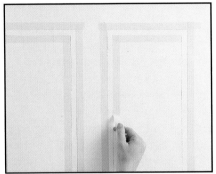

The plain flush doors in this modern hall looked very boring, so to add a little character they have been stencilled with four grey borders to give a panelled look. Start by marking out the panels with pencil lines, using a long ruler and set-square for accuracy. The borders should be about 1.5cm (⁵⁄₈in) wide, with the space at the bottom of the door greater than the top and sides.

Use long strips of masking tape to mask off around the border, on both sides. Press down the tape with your fingertip to prevent paint from seeping underneath and cut the corners neatly with a sharp craft knife. On an old plate, mix up some white, grey and black quick-drying stencil paints. If the door paint is very shiny, lightly sand the border area first to key the stencilling.

If your light source is on the right, start by stencilling the left hand side of each panel in a medium grey, dabbing the paint on thinly and evenly. Mask the top and bottom corners of this line with tape to form a 45° angle (like the mitred corner of a frame). (If the light comes from the left hand side, start stencilling on the right hand side of each panel.)

Leave to dry for a few minutes and remove the angled corner tapes. Then stencil the top and right hand border in dark grey. (Top and left hand border, if light comes from the left.) Mask the corners at an angle, as before. Stencil a thin, even coating of colour, getting slightly paler towards the bottom of the panel.

Lastly, stencil the lower border in pale grey as it will theoretically get the most amount of light. Leave to dry and very carefully pull off the masking tape. For economy, these tapes can be used several times. Stencil all the other panels on the door and then clean off the pencil marks with a damp cloth when the paint has dried.

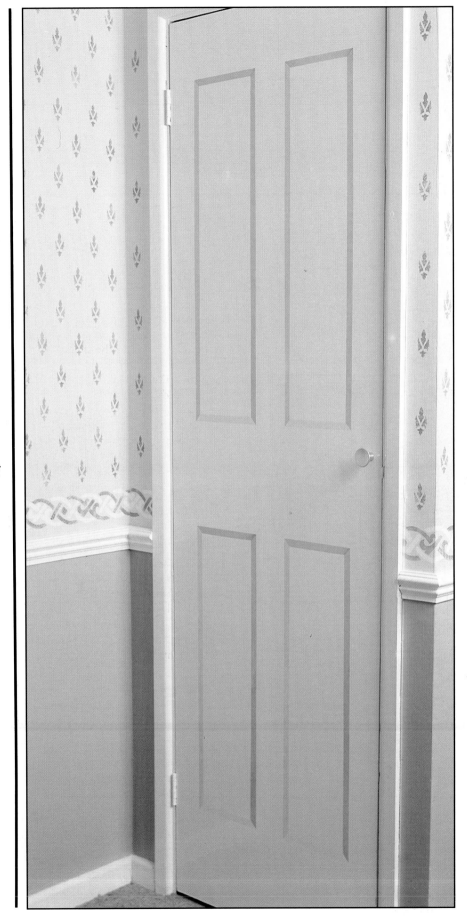

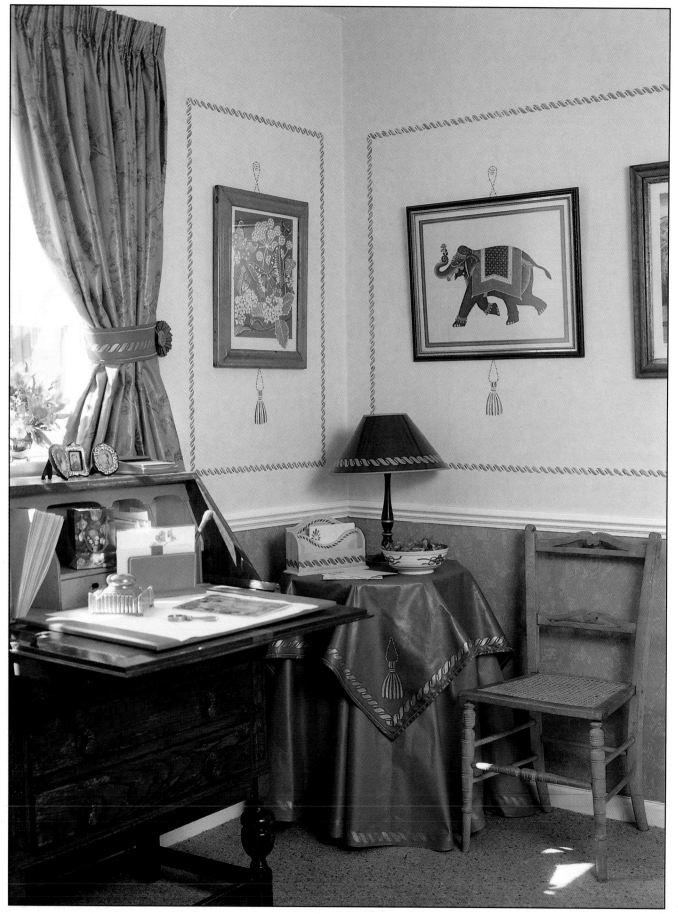

Choose two or three warm colours and subtle textures for a rich, elegant mood in a small study. Don't worry that it will make the room seem smaller – privacy is important! Keep the stencilling classically simple to stop it becoming too distracting. Pictures are important and these are accentuated by a two-colour rope border that can be stencilled around a group of prints to make an attractive 'frame'. The loop and tassels add interesting detail – double tassels for large pictures and single ones under smaller prints. Below the dado rail is the boldest colour with a paler version ragged on top, giving an almost leather-like quality.

The accessories are simple but become part of the whole theme with touches of the rope border in either the same shades or with gold and copper lustre to add sparkle.

The chintz tablecloth and re-vamped wooden tablelamp and shade look rich and expensive in the matching colours but imagine the same items stencilled in shades of pink and peach on cream and white with a touch of silver. A transformation, making them look pretty and delicate to fit perfectly into an alcove in a guest bedroom or landing. Have fun experimenting with the designs in a wide range of colours and situations to change the mood and style.

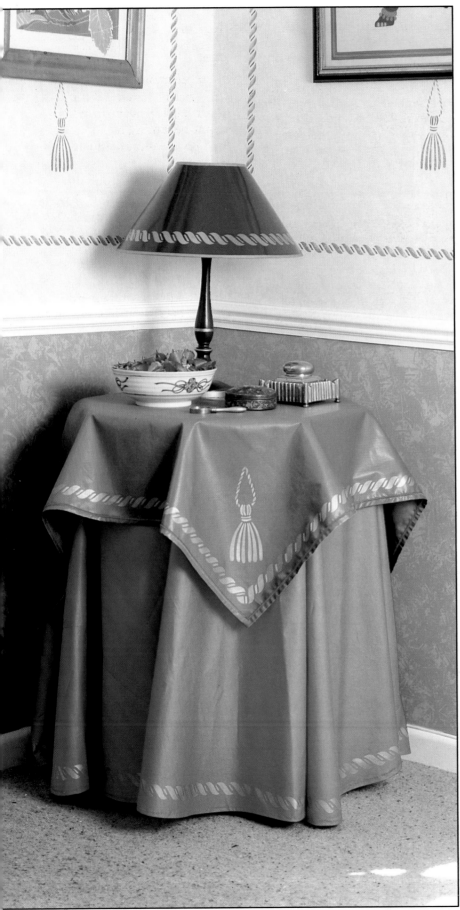

Make a round, full-length table-cloth and a square top cloth for a circular or hexagonal table. Measure twice the width of the table for the square cloth and cut out in green chintz. Tape the straight rope border stencil near the edge of the fabric. Dip the brush into gold lustre fabric paint, wipe off excess and then dip into gold 'bronzing' powder tipped on to a piece of velvet.

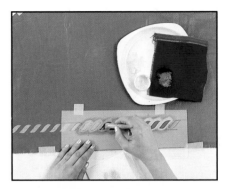

Stencil all around, using the corner stencils as necessary (see page 31). Tape on the other stencil in the set and use silver lustre fabric paint and silver 'bronzing' powder to finish the rope design. Use the velvet to dispense the silver powder on to the brush sparingly and evenly. Stencil a tassel in each corner too. Leave to dry for several days then set with a hot iron.

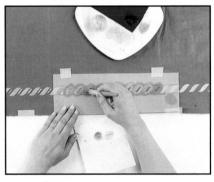

Turn under a narrow hem all around the raw edge of the cloth and press, then pin in place. Set the sewing machine on to a very close spaced zig-zag stitch to look like satin stitch. Sew all around in contrasting thread to make a decorative border that neatens the raw edge.

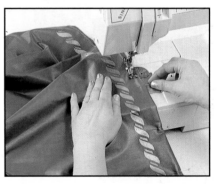

To work out the radius of your round cloth, measure from the centre of the table down to the floor. Join widths of chintz to make a square of fabric measuring twice the radius. Fold the fabric into four and pin. Insert a drawing-pin into the corner that is the centre of the fabric. Attach some string tied to a pencil, making the distance from the pin equal to the radius. Now draw an arc.

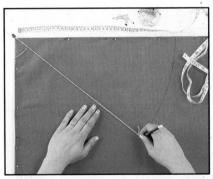

Cut out the cloth 1.5cm (⅝in) outside the arc, through all four layers to make a circle. Unpin, open out and press. Using a curved version of the rope design, as for the lampshade, stencil the edge of the cloth in the same way as the square one. Turn under the raw edge and work satin-stitch using matching colour thread.

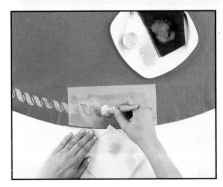

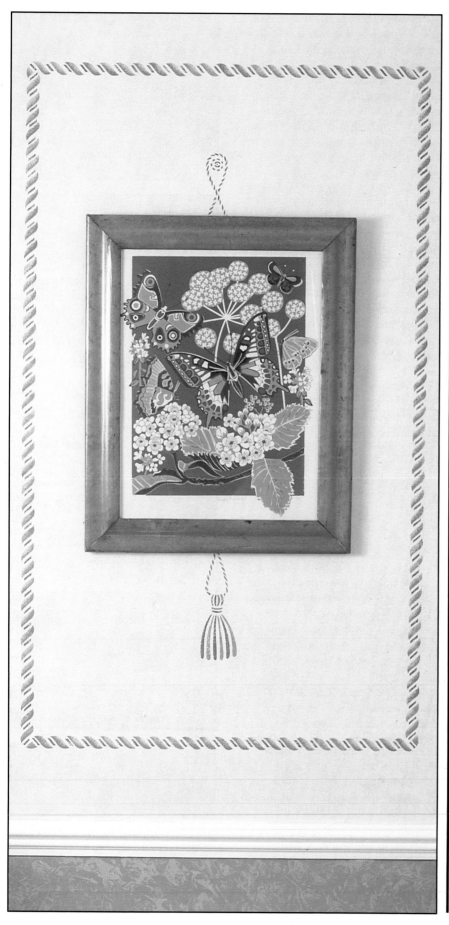

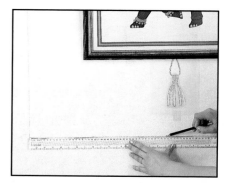

Draw and cut out the corner and straight rope border design, plus the loop and tassel designs, from page 31; cut two stencils for each. Hang up a group of pictures on your wall. Temporarily tape a loop and a tassel stencil sheet in place and then mark a pencil line for the border. Use a plumb-line, set-square and long ruler for accuracy and leave an even margin.

Starting in one lower corner, tape the rope corner stencil in place. Mix up quick-drying stencil paints and stencil lightly, accentuating the colour along the lower edge of each shape to resemble a shadow. Stencil in the second colour, matching up the dotted register lines and the straight, edge lines.

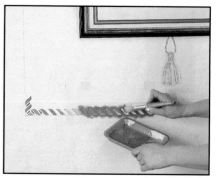

Now, stencil away from the corner, using the straight rope stencil. Move the corner stencil to the far lower corner and stencil up to it, to match the pattern. Move the border very slightly, if necessary, to join the design perfectly. Work all around the panel in both colours and leave the border to dry.

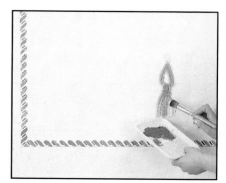

Remove the picture and stencil both the tassel colours to match the border. You can use a single tassel, placed centrally under a small picture, or a double tassel under a large picture. In the latter instance, try out the angles to overlap the tassels on paper first, then work on the wall. Make sure the tassels are placed exactly under the centre of the picture.

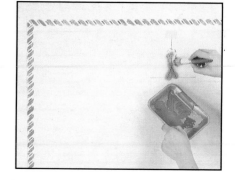

Lastly, stencil the top loop over the picture in the same way. Mark the exact position by running a pencil horizontally along the top of the picture frame and then marking a vertical plumb-line down to the centre of the tassel. The ends of the loop should disappear behind the picture frame to complete the rope hanging illusion.

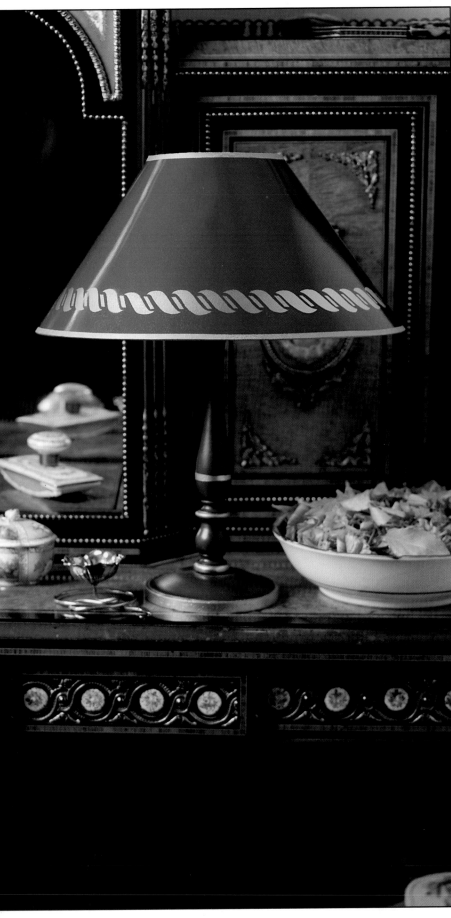

This old, turned wooden lamp base was repainted to give it a new lease of life. Sand the lamp base and spray with several coats of green paint. Leave until touch-dry between coats, and for at least a day once finished, to dry hard. Then press strips of masking tape around the lamp base to leave several narrow bands exposed.

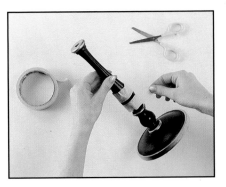

Wrap tissue paper around the lamp base, taping it in place to protect it from the gold spray. Shake a can of gold household paint thoroughly to mix and then spray several light coats to colour the exposed areas. Carefully remove the tissue paper and pull off the tape, then leave each stripe to dry thoroughly. Add as many stripes and borders as you like.

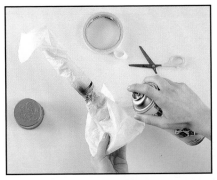

The gold-edged lampshade has been decorated with a rope design border from page 31. Use the same method as for the hall table on page 24 to curve the design to fit. Cut one stencil. Tape it on to the shade and then draw on the curved lampshade edge to align the pattern correctly each time

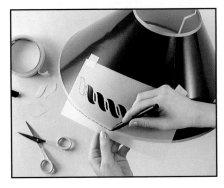

Cover the whole lampshade with tissue paper to protect it from overspray, just leaving the stencil exposed. Tape the paper in place, all around, on to the acetate and then stencil using gold household spray. Work about 30cm (12in) away from the shade and apply several light coats. If necessary, spray glue on to the back of the stencil to hold it pressed flat against the shade.

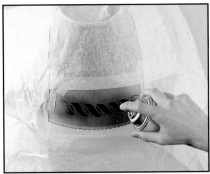

Work around the shade, carefully peeling off the acetate as soon as you have finished stencilling. Leave for a few moments to become touch-dry and place the stencil further along, matching the pattern carefully. Slightly adjust the spacing, if necessary, to match up the design where the beginning and end meet.

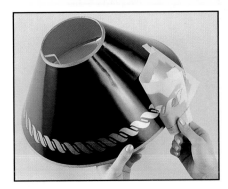

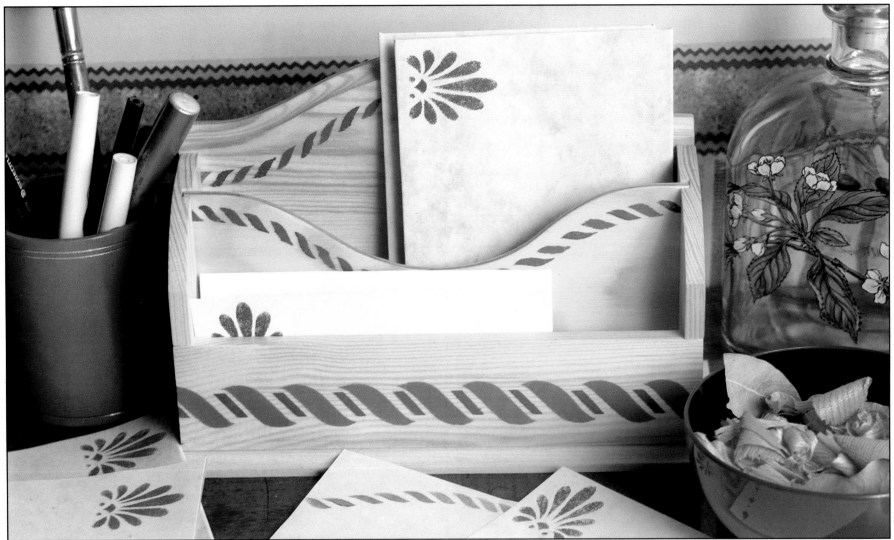

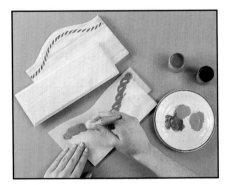

D ecorate a simple DIY pine letter rack, then stencil notepaper to match, for a lovely gift or a smart desk accessory. Sand the wood smooth and cut out two stencil sheets from the small curved rope design opposite. Tape the first stencil on to the wood and use quick-drying stencil paints, mixed up to match your decor, to stencil the first half of your design.

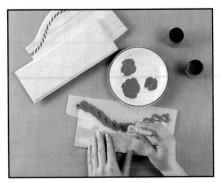

Match up the remainder of the design on the second stencil sheet and paint the second colour. Temporarily assemble the four walls of the letter rack with tape and stencil the large rope design (also opposite) around the lower edge of the box in the same colours.

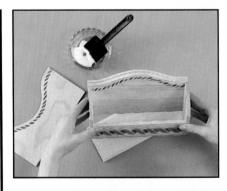

Now glue the box together using PVA wood glue. Begin with the four walls, then, when dry, glue these to the base. The centre section will then just slide into place. Glue this if you wish. Varnish the letter rack with several coats of clear polyurethane varnish to give a smooth, durable finish and to protect the stencilling.

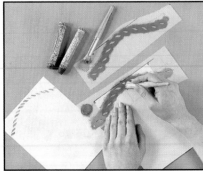

Choose an assortment of notepaper and envelopes in subtle tones to go with your letter rack. Use the same stencils to decorate the top of some sheets, working with oil-based stencil crayons. Rub a little crayon on to a corner of the stencil or a spare piece of acetate and then collect the colour on to a brush. Stencil the colour on to the paper using a circular movement.

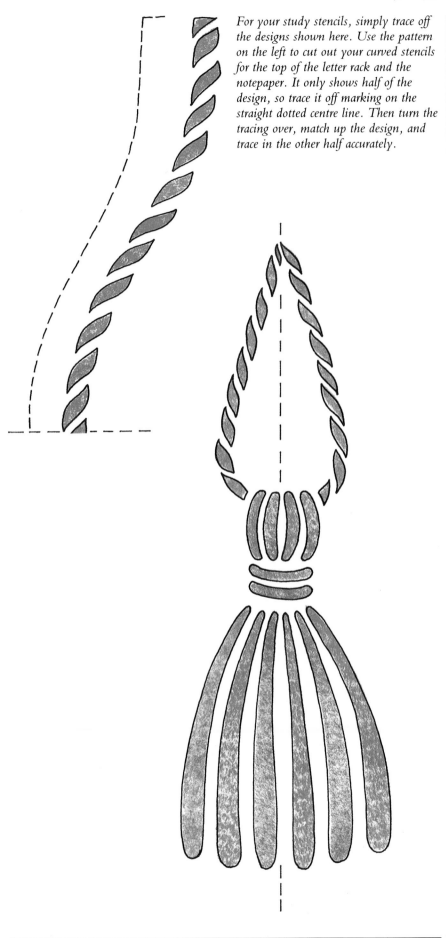

For your study stencils, simply trace off the designs shown here. Use the pattern on the left to cut out your curved stencils for the top of the letter rack and the notepaper. It only shows half of the design, so trace it off marking on the straight dotted centre line. Then turn the tracing over, match up the design, and trace in the other half accurately.

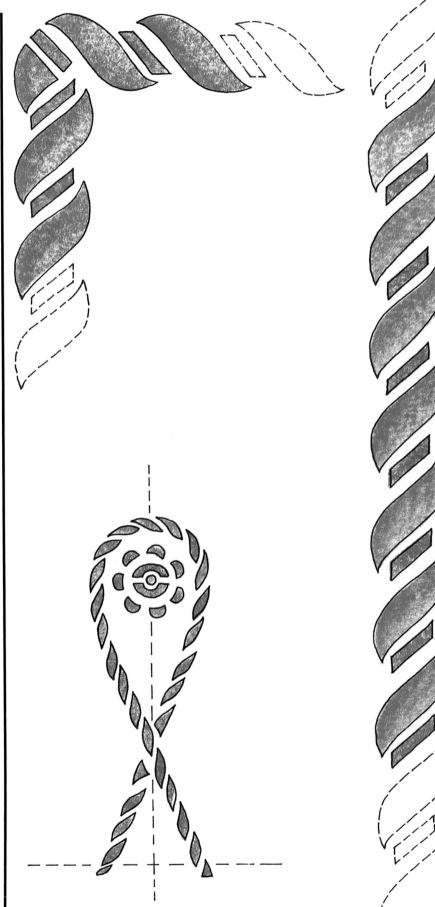

BLUEBIRD BEDROOM

Transform an old attic into a dream bedroom, perfect for a little girl of any age. The detailed bluebirds are reminiscent of early Japanese designs and look charming with or without bows. This is a most adaptable design which is especially useful in a room of this style with lots of varying ceiling levels and roof angles to take into consideration. Notice the angled design leading up to the bedhead (which, incidentally, used to be a chimney breast). The birds forming this border are adapted from the right-hand bird on the original stencil design. The upper wing has been omitted and the birds are facing right and left alternately. To get in close to the ceiling like this, the easiest way is to cut a stencil featuring just the two birds, one reversed.

Continue the blue bird theme throughout the room, adding matching decorations to old furniture that has been renovated and painted at very little cost. Even the Lloyd Loom chair sports a bird and bow stencil but in a bolder design to suit the woven texture of the chair. Other ideas for a room like this are stencilled bedlinen or curtain fabric, a bedside mat, or you could even stencil the floorboards if you're feeling really industrious.

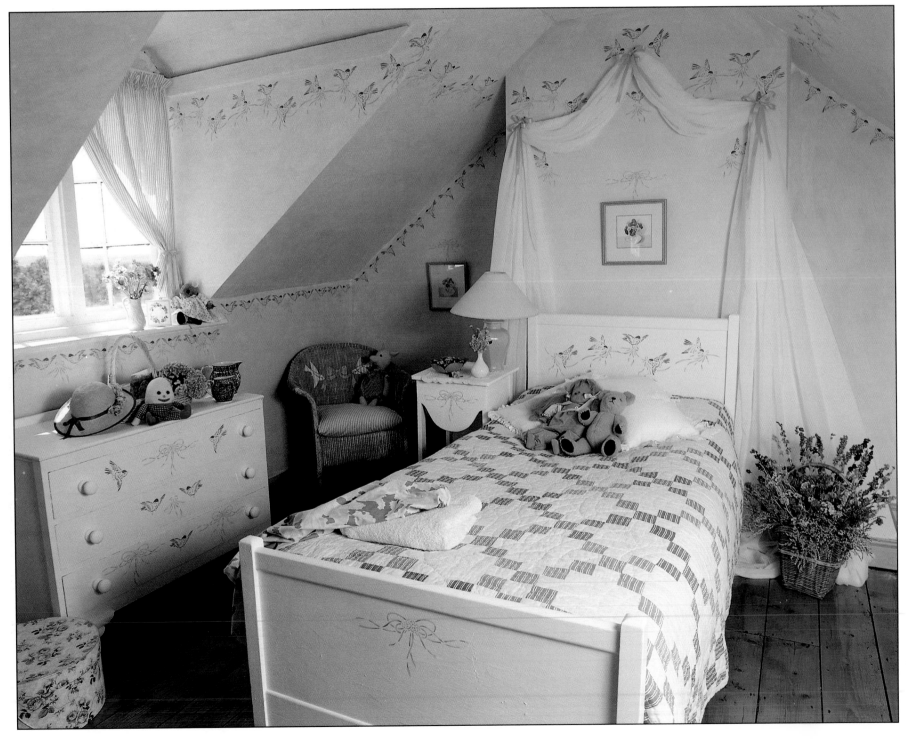

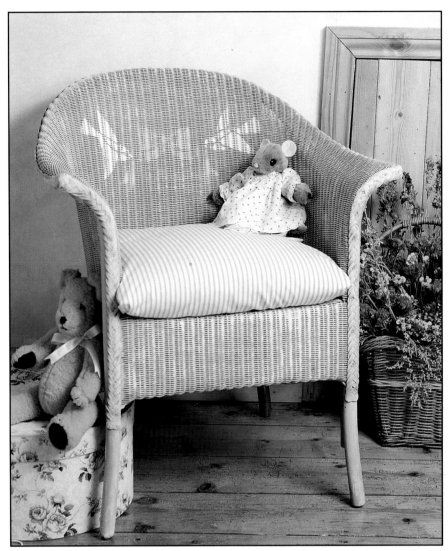

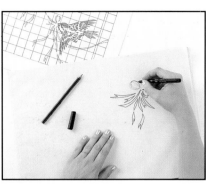

You will need to adapt the original bluebird pattern for this prettily decorated chest of drawers. Trace off the central bow from page 35 and turn the design slightly so that the ribbon tails hang vertically. To balance the bow, sketch in another loop of ribbon on the left. Also use the bow design on page 37.

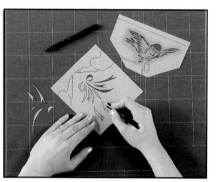

Trace off the new bow design on to a small piece of acetate using a fine waterproof felt-tipped pen. Mark the position of the bird stencils on either side to align the design when stencilling. Cut out the shapes carefully using a sharp craft knife and a cutting mat. Also make a bird stencil. Alternatively, use part of the complete stencil if you have one already made.

If you are only using part of a complete design, mask off the areas of stencil you do not want with paper and masking tape. Mark the centre of the drawer with a pencil line and stencil either side, reversing the stencil as needed. Use quick-drying stencil paint over a base coat of emulsion and, once dry, finish off with a coat of clear varnish.

A painted Lloyd Loom chair is an ideal accessory for this child's bedroom. As the wall stencil is too detailed for the texture of the chair, a bolder version of the design has been chosen. Use the pattern on page 37 to cut three stencils from acetate. Tape the bow stencil centrally on the chair back and mask all around. Spray with household spray paint in soft peach.

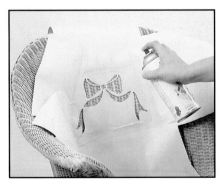

Position a bird stencil on the left of the chair beside the bow. Tape in place and mask as before. Spray the bird in white. Spray several thin coats from about 30cm (12in) away, until the weave of the chair is well covered but not clogged. Leave to dry, then carefully remove the stencil and mask. Repeat with the other bird stencil to complete the design.

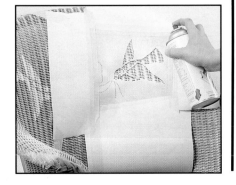

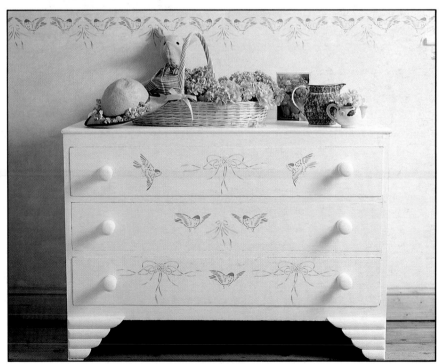

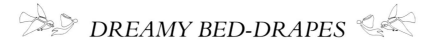

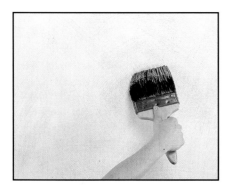

M̲ake this simple bedhead decoration using stencils and lots of inexpensive buttermuslin. Start by painting the walls in white emulsion. When dry, mix up a pale blue wash from very diluted sky blue emulsion paint. Use a large brush and swish on lightly over the white to give a soft, slightly streaky finish. If some areas are too strong, soften with a damp cloth whilst still wet.

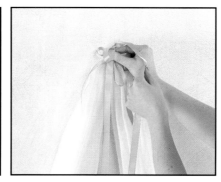

Find the centre point about, 150cm (5ft) above the bed. Drill and plug a hole and screw in a small brass hook. Find the centre of a 16m (18yd) length of buttermuslin. Gather it up across the width and tie a bow of peach satin ribbon to hold it in place. Tie another bow on to the hook and around the muslin so that you have a double bow. Trim the ribbon ends at various lengths.

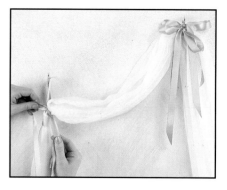

Mark either side of the bed about 30cm (12in) below the centre hook. Drape the muslin to find the best shape and insert two brass hooks at the appropriate points. On the buttermuslin, mark equal distances either side of the centre with tape. As before, tie two bows around the muslin just above the tape, and attach to the hook. Remove the tape and hem the drapes.

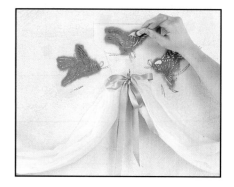

Draw and cut out stencils of individual birds from the design on page 35. Tape these on to the wall around the hooks holding up the muslin. Stencil with quick-drying stencil paints and a small stencil brush. Mix up a soft blue-grey to tone with the background. Clean the stencils in water straight after use as the tiny holes in this design can easily fill up and get blocked.

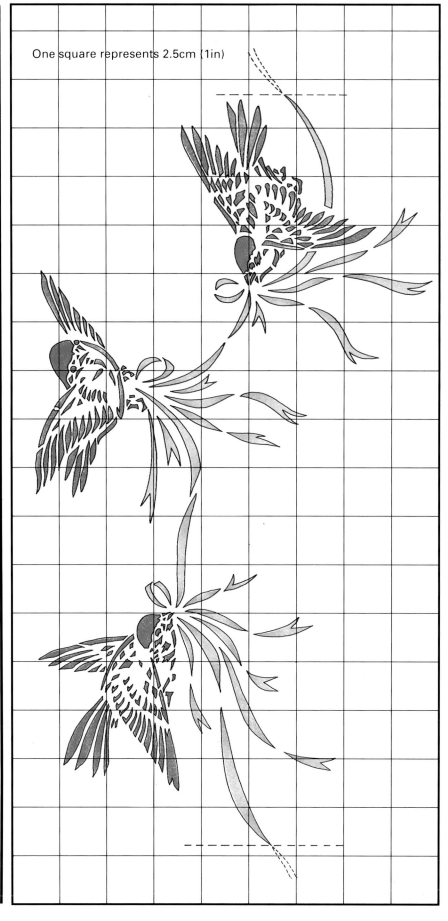

One square represents 2.5cm (1in)

Use this delicate bow to 'hang' small pictures in your bluebird bedroom. The ribbons at the side interlock so you can also use it as a pretty border pattern. Trace off and cut out the design on page 37 onto acetate. Tape the stencil just above the picture so that the ends of the ribbons will disappear behind the frame. Stencil with quick-drying stencil paint in soft peach.

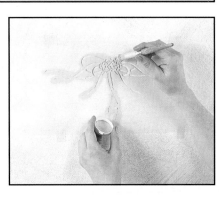

When the paint has dried slightly., use a clean brush to lightly dab on some terracotta colour stencil paint. Do this where the ribbons twist and overlap to give a 3-D effect and make the ribbon look almost shiny. Blend the terracotta paint into the soft peach to avoid a sudden colour change.

Follow the pattern on page 35 to make your full-size stencil. Trace off the bluebirds on to a sheet of clear acetate using a fine waterproof felt-tipped pen. Also trace off some parts of the peach bows, using a dotted line, to help position the stencil. Mark the top and side lines as register marks, then cut out the bird shapes using a craft knife.

Make another stencil for the bows. Mark a faint horizontal pencil line along the wall to line up with top register mark on stencil. Tape the stencil in position and, using soft peach quick-drying stencil paint, stencil the bow design. Keep the paint fairly thin and leave to dry. With a clean brush and terracotta paint, dab the areas where the ribbon twists to give a 3-D effect.

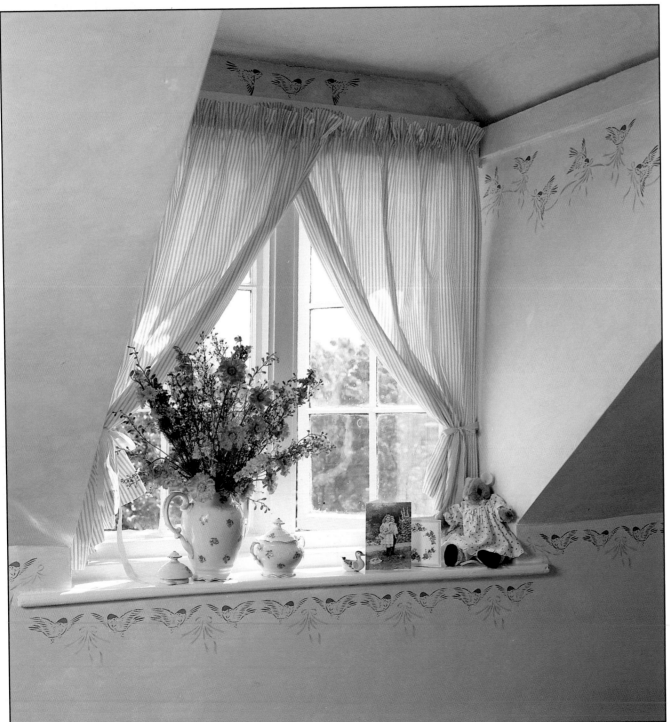

Using the bluebird stencil, tape the acetate in position, lining up your register marks and matching the dotted lines with the stencilled bows. Carefully dab slate blue stencil paint over the birds. Make sure the whole design is covered but keep the brush fairly dry to avoid paint seeping underneath. Wipe the surface often to prevent small holes in the stencil becoming clogged.

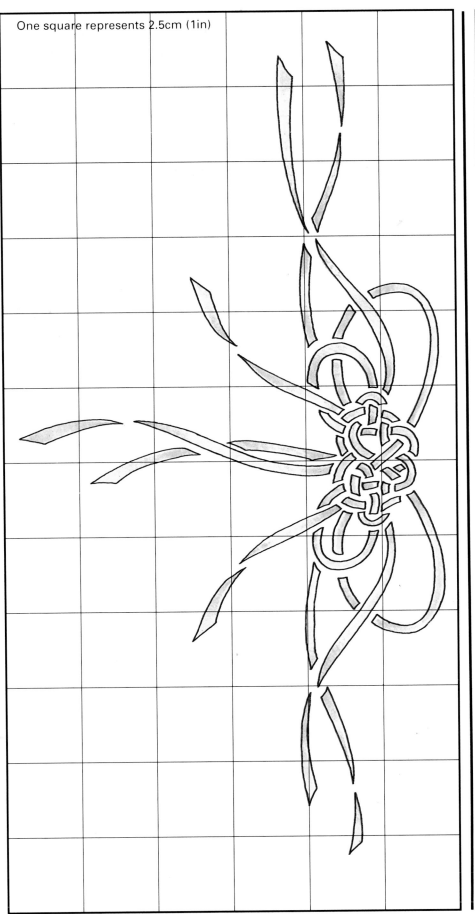

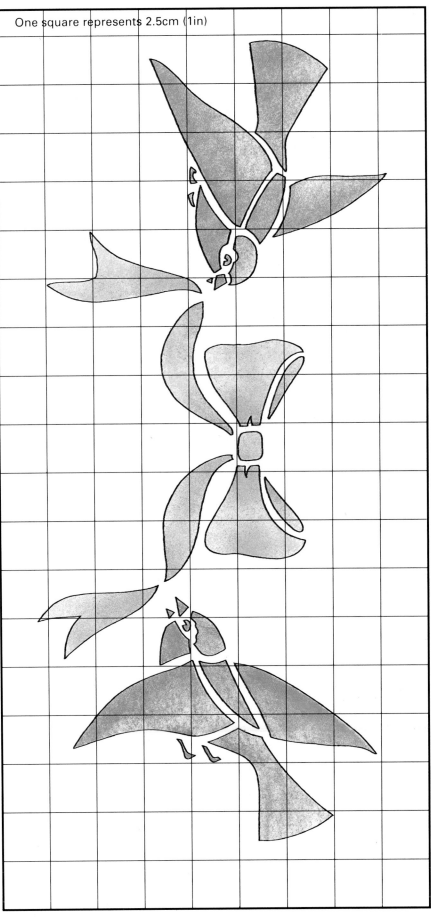

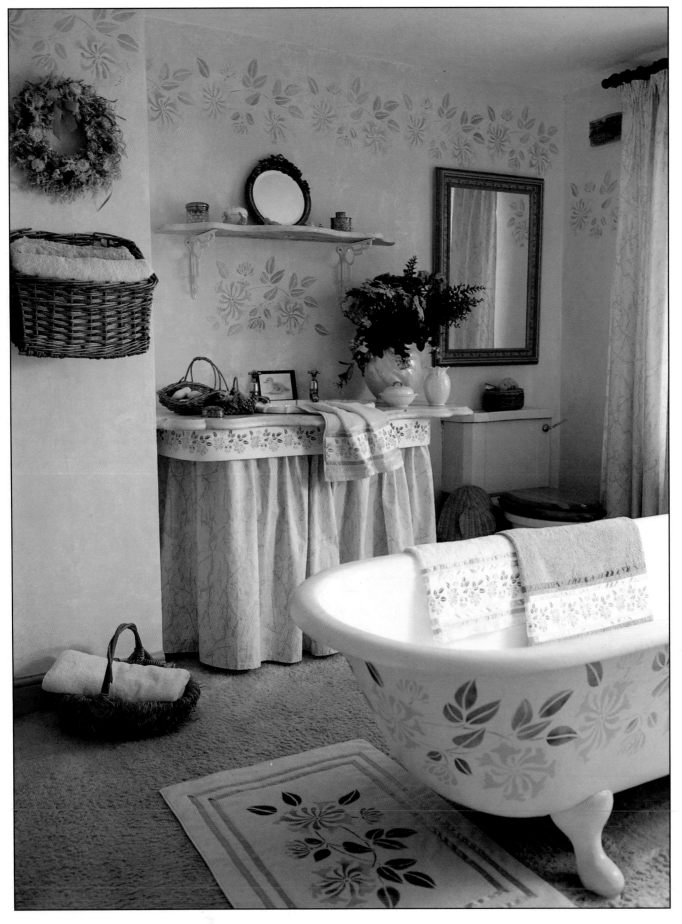

Bring a touch of sophistication to a simple bathroom with this flamboyant honeysuckle stencil. Even the traditional roll-top bath can be restored and decorated to make it a stunning feature standing in the centre of the room. You can use inexpensive household spray paints for this, stencilling after you have coated the outside with a smooth protective spray finish. The design works equally well as a tiny border stencilled on fabric to decorate plain towels or enlarged and sponge stencilled on to roughly sponged yellow walls. Use it as a single motif or join several to make a flowing border pattern. Bathrooms can so often be rather 'cold' with the traditional use of pastel colours. Stencilling provides the ideal opportunity to develop a whole new approach to decorating your bathroom.

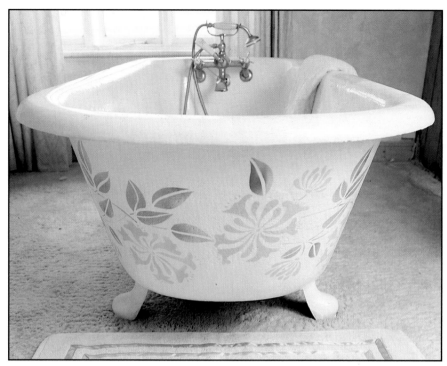

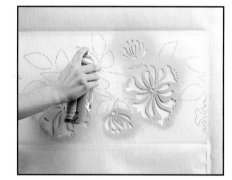

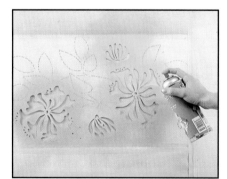

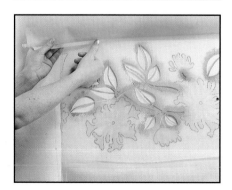

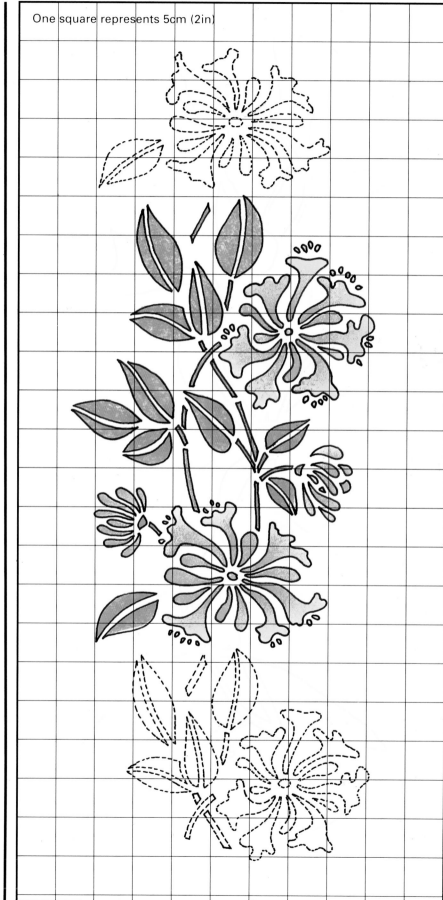

One square represents 5cm (2in)

E nlarge and cut out two stencils from the honeysuckle design opposite. Clean the outside of the bath thoroughly – you can spray paint this first if necessary. Spray glue over the back of the first stencil and tape in place. Mask all around with plenty of waste paper to protect from overspray. Using household spray paint, held about 30cm (12in) away, spray the flowers lightly in yellow.

Leave to dry for a few moments. Meanwhile, shake a can of pink spray paint to mix it thoroughly. When the first colour is touch-dry, spray the centre of each circle of flowers with a burst of pink to subtly shade it.

Tape the leaf stencil in place, lining up the flowers with the dotted lines on the aeetate. Tape waste paper all around as before and lightly spray the leaves in green. Add a little extra green in a few places to liven it up. Stencil all around the bath, then leave the paint to dry thoroughly before use.

To create this beautiful effect, first paint your walls in white silk vinyl and then sponge pale, sunny yellow emulsion paint over the top to make a warm, cloudy effect. Dip a large, damp natural sponge into a saucer of paint, taking care not to overload the sponge. Dab off the excess on to a spare piece of cardboard, then dab on to the wall in an even pattern.

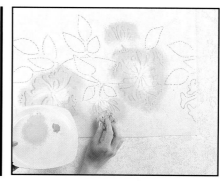

Enlarge and cut two stencil sheets from the design on page 39. Lightly mark the desired level on the wall and tape the flower stencil in place. Use a small piece of natural sponge and dip it into a saucer containing pale peach or yellow stencil paint or emulsion paint. Tester pots are ideal for this purpose. Dab on to the stencil around the edge of each circle of flowers.

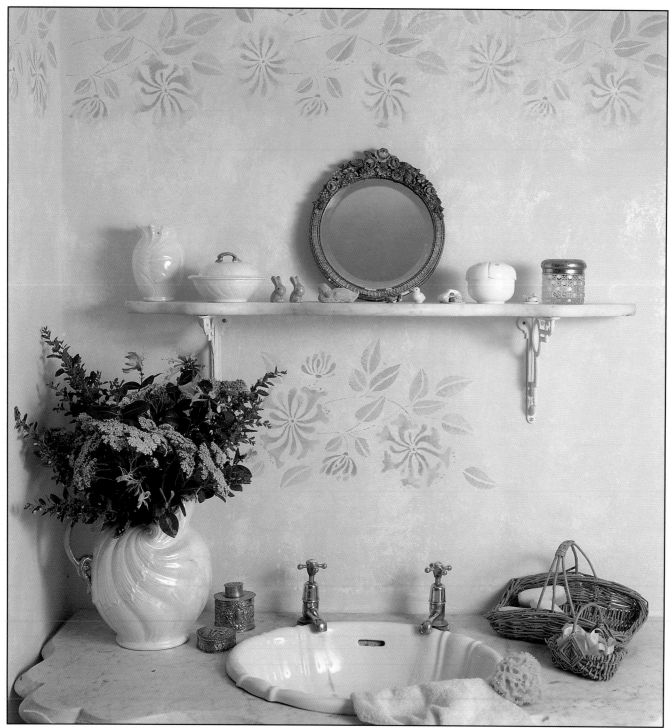

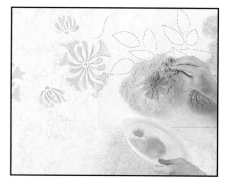

Mix up a subtle pinky-orange and sponge-stencil this on to the centre of each group of flowers. Gradually blend the pink with the yellow to make a soft orange. Stencil all the flowers around the wall like this, linking the design with the dotted lines on the stencil.

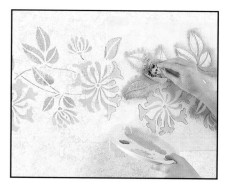

Tape on the leaf stencil and mix a few shades of green from lime to emerald on an old plate. Use another piece of sponge to stencil the leaves and stems. Try to vary the shades of green over the design, to give added interest. Dab lightly for a mottled texture that blends with the wall sponging.

Pin or tape a piece of old fabric on to your work surface. Tape a strip of white poplin on to this and draw registration lines in faint pencil to match those on the stencil. Lay the green stencil on top and apply a mixture of green and yellow fabric paints with a dry brush.

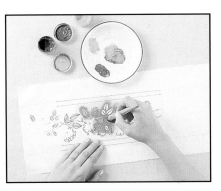

Complete the green border, then stencil the yellow flowers and buds. Start with yellow around the outer parts of the flowers, then blend pink in the centre. Leave the fabric paint to dry, then fix it following the manufacturer's instructions. Cut out the stencilled fabric along the pencil lines to fit the width of the towel.

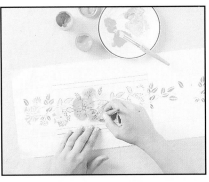

Sew the stencilled strip along the long raw edges on to the towel; turn under the short raw edges to neaten. Pin a length of green satin ribbon over both raw edges and stitch down both sides of the ribbon. Sew on two more pieces of narrower peach ribbon either side.

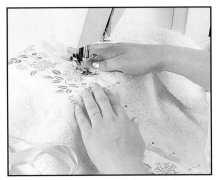

To make a stencil for the bath mat, you must enlarge the design on page 39. You can do this by following the squares on the printed pattern and drawing the design square by square on to a larger grid. The squares of your grid should measure 5cm (2in) each.

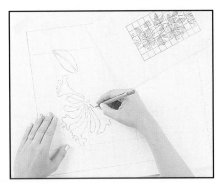

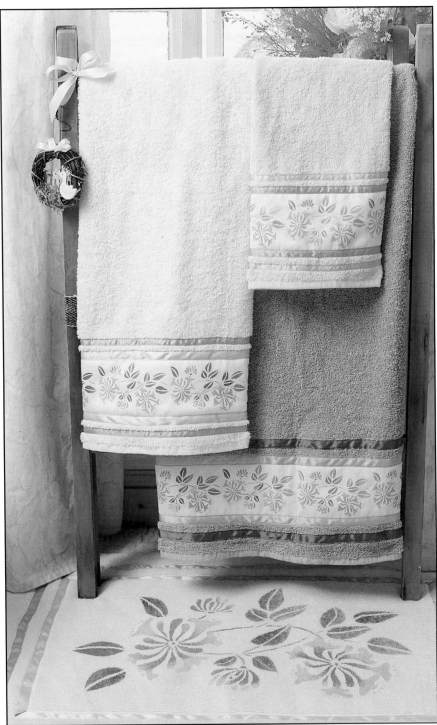

Trace the yellow part of the honeysuckle design straight from page 39 on to clear acetate using a fine waterproof felt-tipped pen. Draw in the upper and lower registration lines and also a few leaves to help position the stencil accurately. Using a craft knife and cutting mat, cut out the yellow parts of the design. Make a separate stencil for the green leaves.

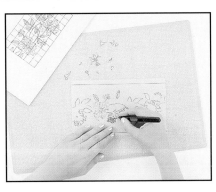

Use fabric paints to stencil one large honeysuckle motif on to the centre panel of a plain peach bath mat. First press the mat and tape it to your work surface. Tape the stencil in place and dab fabric paint on to the towelling. You will need quite a lot of paint since the fabric is textured and absorbent. Fix the paint when dry and add ribbons to match the towels.

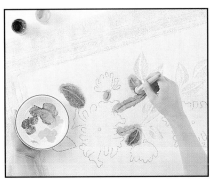

GARDEN POTS

Terracotta flower pots are an ideal medium for stencilling, especially as a beginner's project. Match the designs to your room stencils, or make an attractive mixed collection to arrange in the garden, conservatory or on a patio. Choose small areas from your stencil patterns and repeat these around the pots, or simply sponge paint the pot, masking out areas to leave the terracotta showing through. Create your own designs with simple paper shapes attached with adhesive putty (e.g. Blu-Tack) and strips of masking tape in zig-zag designs. The best paint to use is an oil-based eggshell which will not be damaged when you water your plants. It is also hard wearing, ideal for outside use.

To decorate a pot to co-ordinate with the Honeysuckle Bathroom (pages 38-41), trace off small areas of the large honeysuckle pattern on page 39. Choose single leaves, small flower clusters and groups of two or three leaves. Cut out these stencils in small off-cuts of acetate so that you can position them easily on the curved sides of the flower pot.

Sponge the pot lightly all over in cream eggshell paint. When dry, repeat sponging in pale apricot for a soft mottled base coat. Position stencils in a random design and use masking tape to hold in place. Stencil designs with stencil paints and a large brush, shading from light to dark green on leaves and yellow to pink on flowers. Spray with clear varnish when dry.

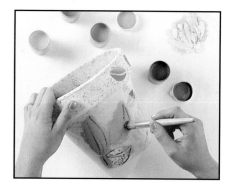

For simple striped design, press strips of wide masking tape vertically down the lower part of the pot and one strip around the rim. Sponge exposed areas of pot with eggshell paint, dabbing off excess paint on to a piece of spare cardboard. Start with a coat of pale green then darker green on top. Carefully remove the tape and add a row of tiny stencilled hearts (page 56).

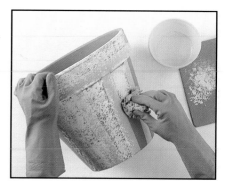

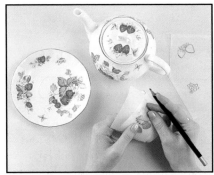

Patterned china was the influence for the strawberry stencil used to decorate a new pine tray. Either use this design and purchase china to go with it or follow these instructions for designing your own stencil to match existing china. Start by taping small scraps of tracing paper to the china and tracing off single leaves, flowers and fruit.

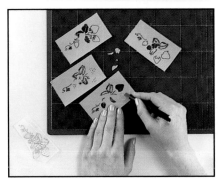

Using the tracings, arrange the various elements of the design into a pretty group and draw the outline. Referring to page 57, turn this drawing into a stencil by creating 'bridges' in the design. Colour it to get the full effect and then make a separate stencil for each colour. Draw all the outlines on each stencil with a fine pen to line them up accurately. Cut out the stencils.

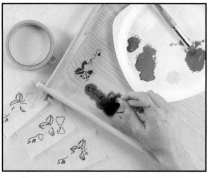

Sand the tray smooth before stencilling. Use the green stencil first, turning it as you work around the tray so that the design interlocks at the corners. Use quick-drying stencil paints and a small stencil brush for each colour. Dip the brush into the paint and wipe off the excess. Then stencil with a firm dabbing stroke to create a speckled texture.

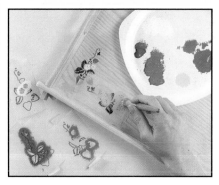

Work one corner at a time, using both green stencils, followed by red then white. Make yellow the last colour as it overlays the other stencils. Leave for a few moments between colours to avoid smudging the paint. You can use small parts of the design to decorate narrow areas around the handle and on the tray sides. When the stencilling is complete, apply clear varnish all over the tray.

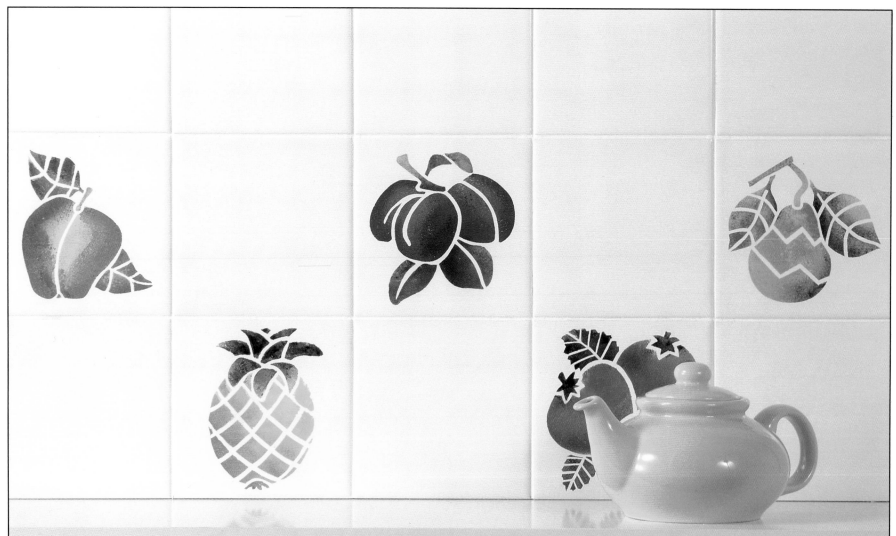

Here's an attractive way to brighten your kitchen — by stencilling your own tiles. Either square up the designs on page 55 (as described on page 7) or draw your own design on to tracing paper. Using masking tape, attach the design to a cutting board. Tape the stencil film on top of the design and cut it out using a stencil knife.

Before you begin painting, wash and dry the tiles to make sure they are free from dirt and grease. Attach the cut stencil to a tile with masking tape. Pour some ceramic paint on to a saucer and dip the stencil brush into it. Dab off any surplus paint on to waste paper, then apply the colour to the required area of the stencil. Start with the lightest colour, then apply the darker tones on top.

Add subsequent colours to other areas of the stencil, again starting with the lightest and building up texture and shade with each application. Wait for the paint to dry before removing the stencil. Then carefully clean up any smudged areas with a craft knife or a paint brush dipped in turpentine. Finally, protect the design with a coat of ceramic varnish.

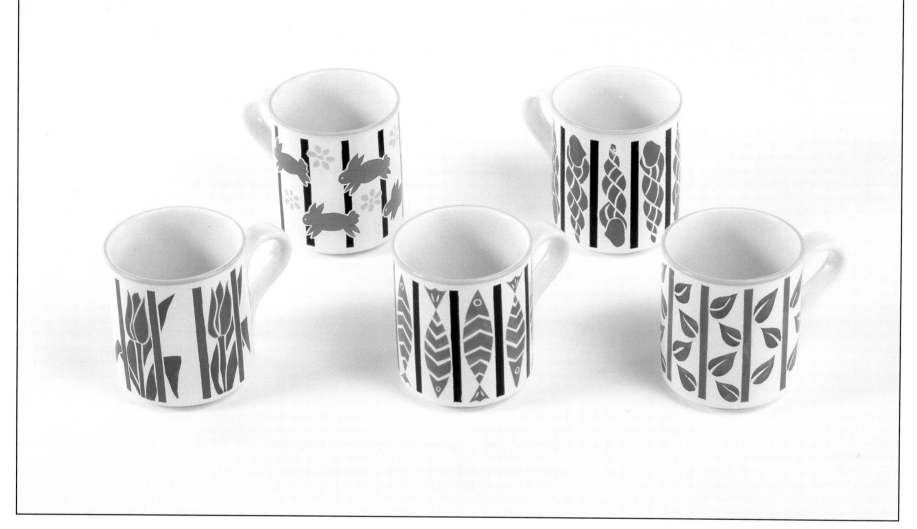

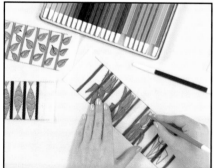

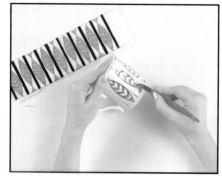

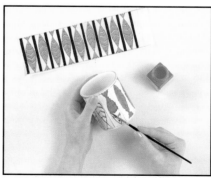

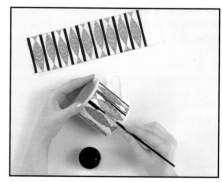

These mugs have been stencilled using low tack masking peel. Choose mugs with straight sides, and not ones which curve out at the top, so that the masking peel will stick properly. Cut out a piece of paper to fit exactly round the mug and, following the templates on page 56, draw the design. Work out your colour scheme using felt tipped pens that match the colours of the paints.

Place the low tack peel on top of the design and trace the design on to the peel using an indelible pen. Pull off the backing paper and stick the masking film on to the mug. Then cut out the design with a stencil or craft knife.

Using ceramic paint and a fine brush, apply the first colour. Try to hold the brush as upright as possible so that you don't get too much seepage under the stencil.

When the paint is dry apply the next colour and so on until the design is complete. Leave to dry, then peel off the masking film. Clean up any rough edges with a stencil knife or a fine brush soaked in turpentine. Finally, apply a coat of ceramic varnish to protect the design.

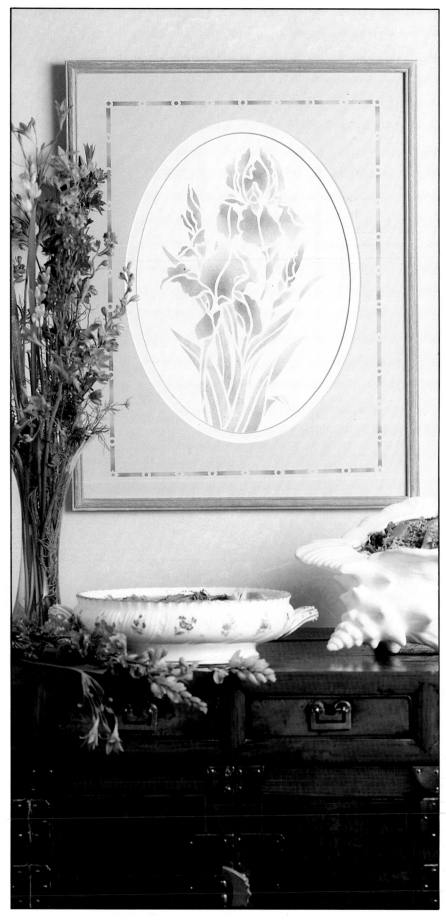

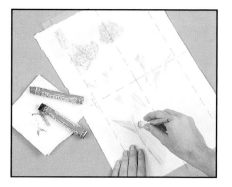

Stencil this attractive iris design on to thick watercolour paper for a linen texture and use wax stencil crayons for subtle colour shading. Size up the design on page 56 and cut three stencils for mauve, yellow and green areas. Tape the green stencil in place and blend together two green crayons. Rub the crayons on to the acetate and then collect the colour on to the brush.

Remove the green stencil and tape the mauve one in position, lining up the vertical and horizontal marks. Blend mauve, blue and turquoise for the flowers, shading the lower petals in mauve and the upper ones in blues, and getting deeper towards the centre of each flower. Lastly, use the yellow stencil. Work the brush in a light circular motion to shade the colours throughout.

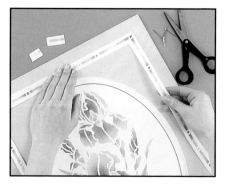

Have an oval mount cut to fit around your stencil. Cut out the border stencil from the design on page 57 and try it out on scrap paper in various colours. Cut these trial pieces into strips and lay them around your mount. Hold them in place with masking tape and then insert a pin centrally at each corner when you are happy with the position.

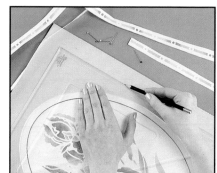

Carefully remove the strips and, very lightly, mark guide lines for stencilling the border using a pencil and set-square. Check the lines are exactly the right distance from the oval shape and parallel to the outer edge. The stencils at the top and sides should be equidistant from the oval and the lower stencil slightly further away to look visually correct.

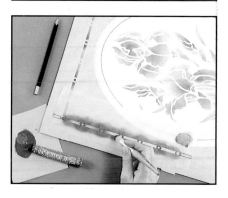

Finally, stencil the border in a single colour using stencil crayons as before. Build up the colour where the strips meet the round spots in the design to add interest. Assemble the stencil with the mount and a piece of glass in a simple frame coloured to complement your flowers and decorations.

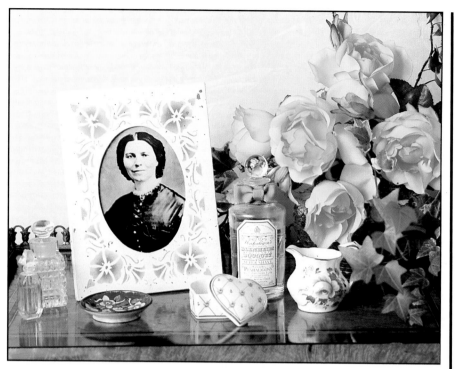

Hang a wall vase in a plain white wall and stencil a bunch of flowers that will last all year. Draw out the design to size from page 57 and cut four stencils, one for each colour. Mark a pencil line where the top edge of the vase will be and tape the first stencil in position. Rub the stencil crayon on to the acetate and collect the colour on to a stencil brush. Stencil with a circular motion.

Tape the other stencils on, one by one, lining up the outlines to register the shapes accurately. Shade the colours slightly darker where the leaves twist and blend the colours into each other for a subtle effect.

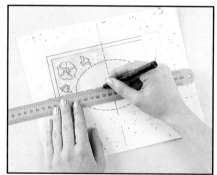

Make this pretty Victorian-style frame for a treasured photo. Using the design on page 56, draw up the shape of your photo frame on to thick cardboard and cut it out. Cut out a larger piece of wrapping paper and lightly draw the cardboard shape centrally. Cut out one stencil for each colour and lay them in place on the paper. Mark the horizontal and vertical guidelines.

Lift the stencil occasionally to check the result, going back to deepen the colour if necessary. Leave the stencil colour to set hard for about a day before positioning the vase to avoid smudging.

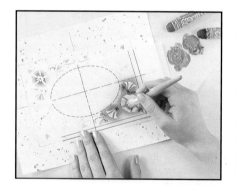

Using pink and green stencil crayons, stencil two opposite corners with flowers and leaves. Rub the crayons on to acetate and then load the brush with the colour for stencilling. Clean the stencils with a rag dipped in white spirit. Then turn the stencils over and use them for the other two corners. Glue the cardboard shape in place on to the back of the stencilling.

Fold over the edges of the paper to the back of the card and glue in place. Cut the central area of paper and snip in towards the oval window. Glue these flaps to the back of the card to neaten. Tape the photo in place and cover another piece of cardboard in the same paper to make a backing piece. Make a narrow stand, cover in paper and glue to the back to complete.

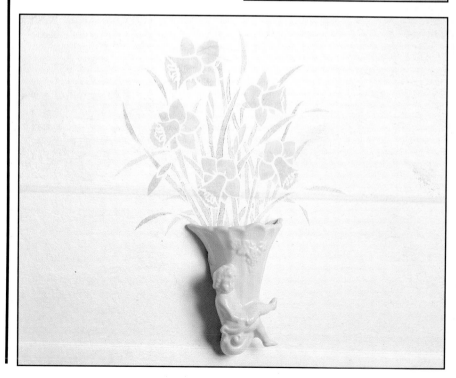

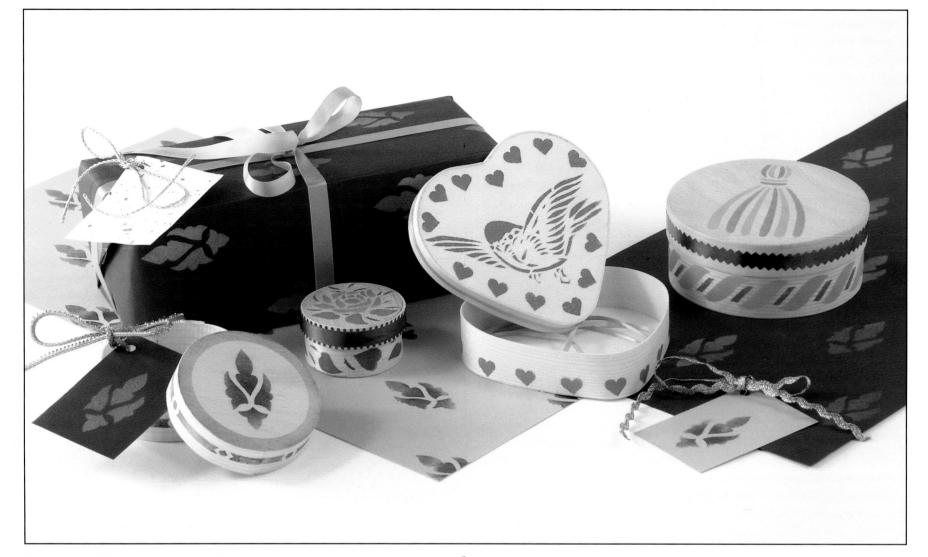

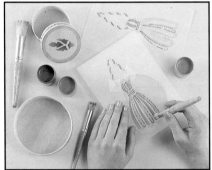

Stencil your own wooden presentation boxes to add a little extra to a small gift. Choose single motifs and use either quick-drying stencil paints or stencil crayons. Mask off a small motif from a larger stencil and tape the acetate in position to complement the box shape. Stencil the box top and sides, mixing designs to create an attractive arrangement.

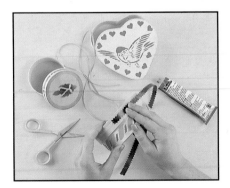

Make a coloured border on the lid by cutting a piece of cardboard slightly smaller than the box top, placing it centrally and stencilling around the edge. Finish off the box by gluing on lengths of satin ribbon, bows or self-adhesive parcel ribbon. You could also line the box with coloured tissue paper.

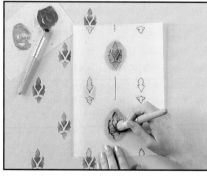

Making your own wrapping paper is great fun for a beginner at stencilling. Choose small, all-over motifs (see pages 22 and 35) and stencil with one or two different coloured stencil crayons. Use plain art paper and work across it, lining up the motifs as shown. Rub the crayon on the corner of the acetate and then collect the colour on to a stencil brush for stencilling.

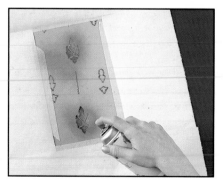

Gold spray on dark paper makes a rich, dramatic gift wrap ideal for a man's Christmas present. Use the same stencil design but tape lining paper around the edge to act as a mask. Spray lightly through each motif, wait a few moments for it to dry, then move on to the next area. Matching gift tags can easily be made by cutting out one motif and gluing it on to folded cardboard.

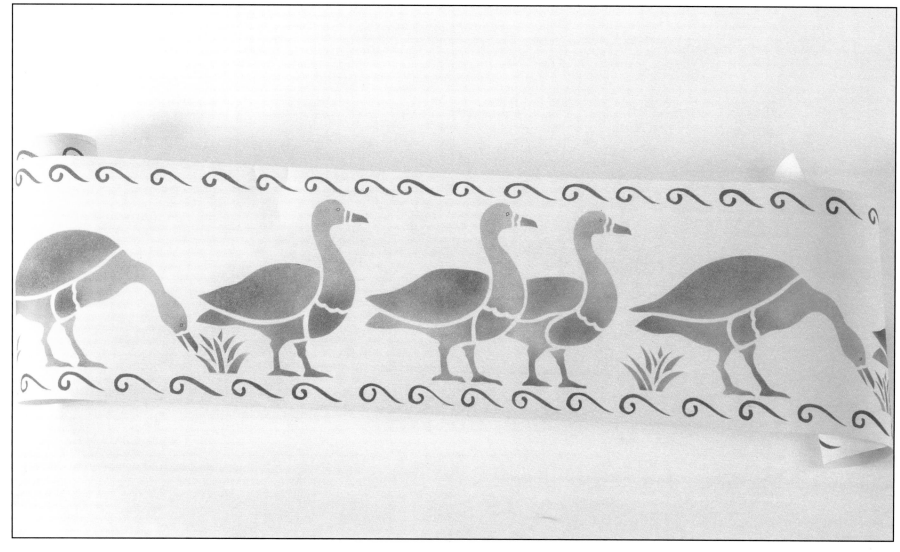

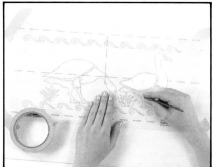

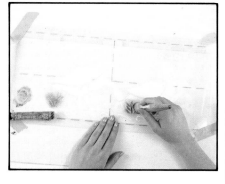

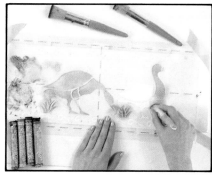

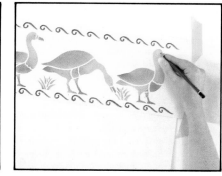

This stencil border is inspired by a 3rd century BC Egyptian painting. First, draw the design on page 55 to the required size, referring to the instructions on squaring up on page 7. With masking tape, attach some stencil film over the design and cut out the shapes using a stencil or craft knife.

You can stencil with either paint or crayons. Stencil crayons have been used here as they give a soft effect, similar to spraying. Position the stencil over your border and tape it in place. Now rub some crayon on to one corner of the stencil film and then dip the brush into the colour. Apply the colour to the area you wish to stencil using a circular motion.

Lighter shades should be applied first, with dark tones added on top to provide shading and depth of colour. It is a good idea to use a separate brush for each colour so that you do not get a muddy effect.

To finish the stencil, colour in the border design in a slightly stronger terracotta colour. Draw the eyes on to the geese using a pencil. When you have finished one section of the border, move the stencil along to the next area and repeat the process. Once you are confident at stencilling, as an alternative to painting a border, you can paint straight on to the wall.

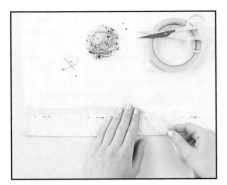

Use a short length of expensive lace as a ready-made stencil to decorate a delicate design on to any amount of bedlinen – sheets, pillowslips or duvet covers. Starting at one end of the wide hem on a sheet, pin on the lace so that the decorative lace edge runs along the edge of the fabric. Tape the two short ends and the straight edge of lace to mask from the spray.

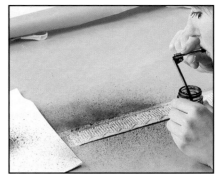

Remove the pins. Lay the sheet on waste paper and mask all around with more paper to soak up overspray. In a small jar, mix black fabric paint (e.g. Color-Fun) with water to give a thin, very liquid consistency. Using a mouth-spray diffuser, blow the dye carefully over the lace. Aim for a light grey, spotty texture that will spread into the fabric. Leave to dry.

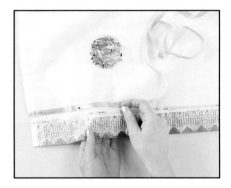

Move the lace along the edge of the sheet and mask and spray to complete the border. Remove all masking and leave to dry for 24 hours. Then use a hot iron to fix the dye. Pin and stitch lengths of grey and peach satin ribbon parallel to the lace edging to decorate further. Alternatively, choose coloured ribbon to match your decor.

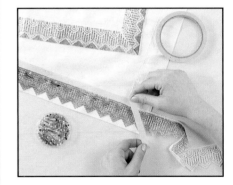

Position, mask and spray the lace, in the same way, around the edge of the pillowslips. When you reach a corner, mask across the lace with tape at a 45° angle to mitre it. Match the lace pattern with the previous side where it meets at the corner. Finally, decorate with ribbons to match the sheets.

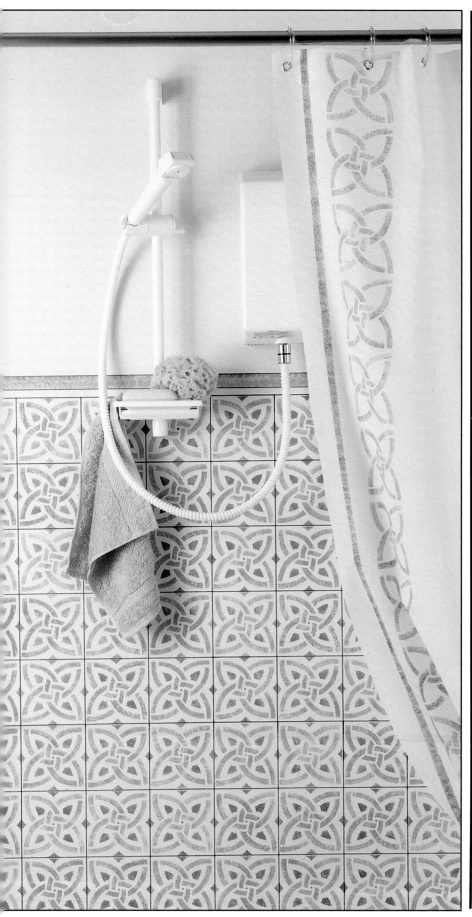

Create a stylish tile effect for a shower or bathroom with this intricate stencil design. Using the pattern on page 57, draw and cut out an acetate stencil for each colour. Carefully mark horizontal and vertical lines for the tile edges around the design to help line it up accurately on the wall. Use a waterproof felt-tipped pen.

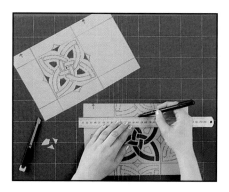

You will need to pencil mark the tile outlines on the wall before you start stencilling. To speed up this process, you can mark and cut out a piece of cardboard to use as a template, as shown. Join up all the marks with a long ruler to create an accurate grid.

Starting at the top, stencil the first colour along horizontally. Use quick-drying stencil paint in turquoise. Dab on with a nearly dry brush for a soft, even texture. Make sure the design is lined up exactly each time and wait a few moments for the paint to dry before moving on. Complete this colour all over the area. Leave to dry.

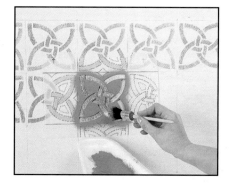

Use the second stencil for the green, working as before until complete. When this is dry, use a thick, green, waterproof felt-tipped pen and draw in the lines between the tiles to look like grouting. To complete, mask two lines with tape above the tiles to make a border. Stencil in blue and green. Cover the area with clear polyurethane varnish to protect the stencilling from water.

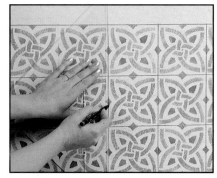

Stencil a plain white shower curtain with a complementary border design. Use only the turquoise stencil sheet and work one row of motifs about 10cm (4in) from the edge of the curtain. Use artist's acrylic paint, mixing the colours to match the tiles, and a stencil brush. This paint is water-resistant and will flex with the fabric. Mask a narrow border line and stencil in green.

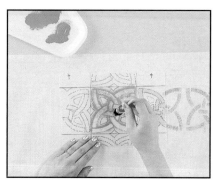

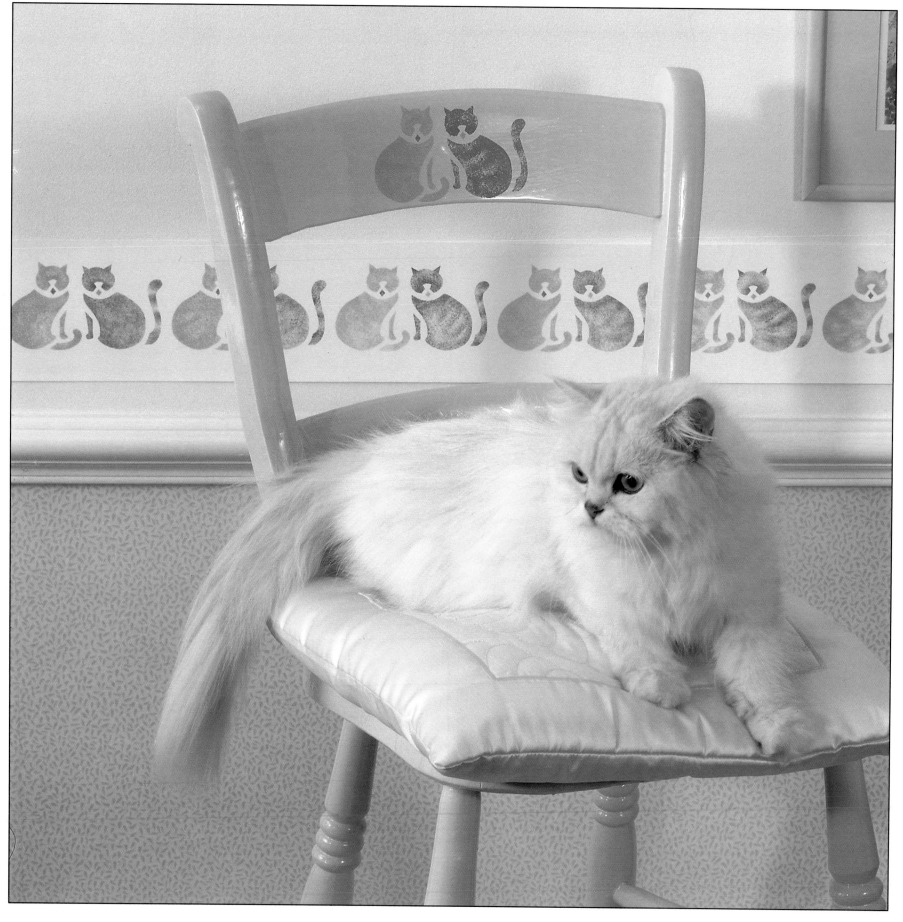

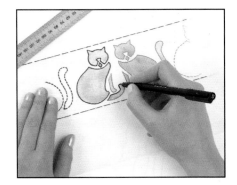

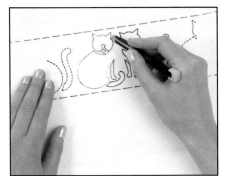

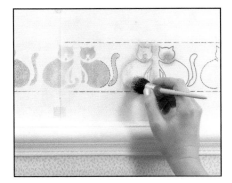

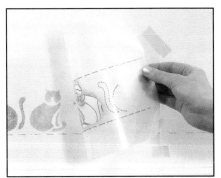

Brighten your bedroom with a charming border of fat felines. Referring to the design shown opposite, cut out an acetate stencil sheet, making it about 10cm (4in) larger all round than the motif. Use masking tape to hold the sheet in place centrally over the design and then carefully trace off the solid outlines and all the dotted guidelines using a waterproof felt-tip pen.

Place the acetate stencil sheet on a flat surface or cutting board and, using a craft knife, carefully cut out the design, following the solid outline. If you intend to use two or more colours in your border, as we have, you can make a separate stencil for each colour, cutting out only the relevant areas on each one.

Using a soft leaded pencil, lightly mark a base line or top line around your wall, measuring carefully to ensure that it runs parallel to your dado rail, picture rail, door frame or whatever. Attach the stencil in position with masking tape, lining up the dotted line with the pencil line on the wall.

Pour a little stencil paint into a saucer. Dip the brush into the paint and dab it on to some dry kitchen paper. Test the brush on a scrap of paper and, when the paint stops looking blotchy, begin to work on the stencil using a light circular movement, going first in a clockwise and then in an anti-clockwise direction.

Lift the stencil away from the wall occasionally to check your progress. When all the shapes have been filled in to your satisfaction, carefully lift off the stencil and reposition it over the next area to be painted. Match the dotted lines over the previous stencil motif in order to keep the designs evenly spaced.

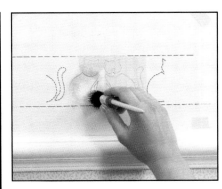

For a multi-coloured design, as an alternative to making several stencils you can use a single one and mask off unwanted areas with tape. Always finish one colour before you reposition the mask and begin to stencil the next colour, and remember to allow the paint to dry between coats to avoid smudging.

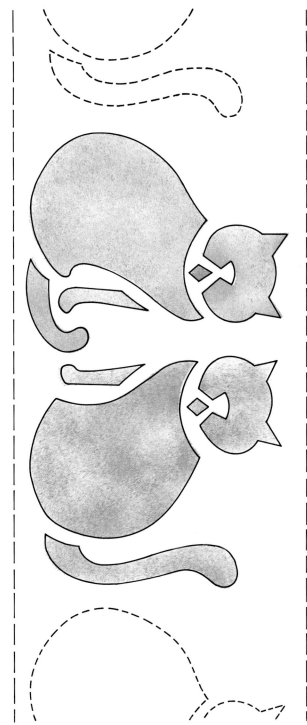

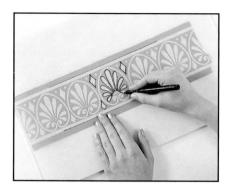

A plain pine mirror frame has been stencilled to echo the wall border. The design has been taken directly from the border by tracing off three or four motifs and simplifying the shapes slightly to make them easier to cut out as stencils. If necessary you can reduce or enlarge the size of the design to fit your mirror frame using the squaring up method.

Try out your design on paper and work out the correct way to angle the motifs to fit the corners. Make two stencils – one for each colour. First trace off the design with a waterproof felt-tipped pen on to an acetate sheet. Then cut out the relevant pieces with a sharp craft knife on a cutting mat. Mark lines top and bottom on both stencils to line them up correctly.

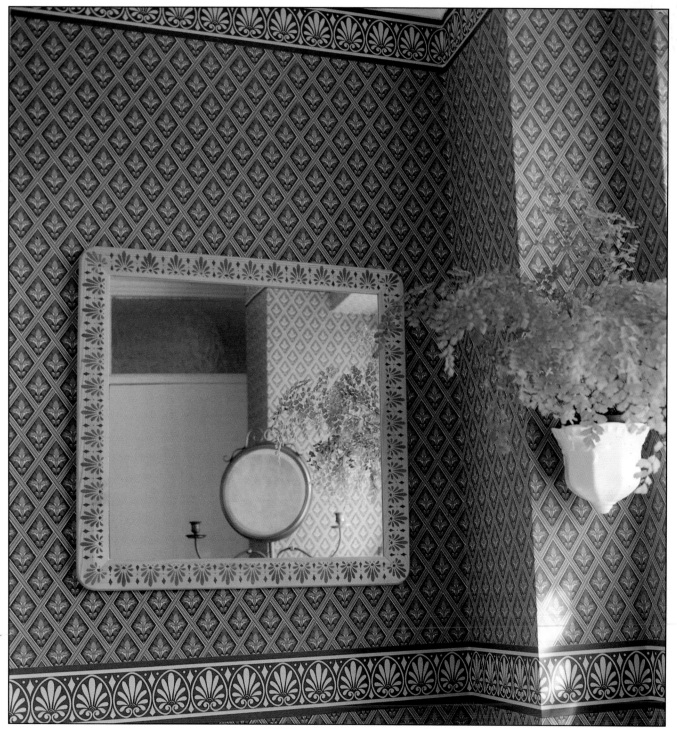

When you have cut the stencils, lay them on to your paper pattern and mark a dotted pen line at a 45° angle at the end of the main motifs to align the corner motif. This will also line up with the mitred corner of the frame so that the spacing of the border is correct when you are positioning the main stencil. Now protect your mirror with a sheet of paper taped in place.

Start with the main motif and stencil along one side. Use quick-drying stencil paints blended to the correct colour and a small stencil brush. At the corner, twist the stencil and position one main motif across the corner. Mark the inner edge of the mirror on the stencil to align the other corners. Apply the second colour next, then finish with a coat of clear varnish.

The following are patterns for the designs on pages 42-54.
Either enlarge them to the required size by squaring them up
(as described on page 7), or trace them directly off the page.

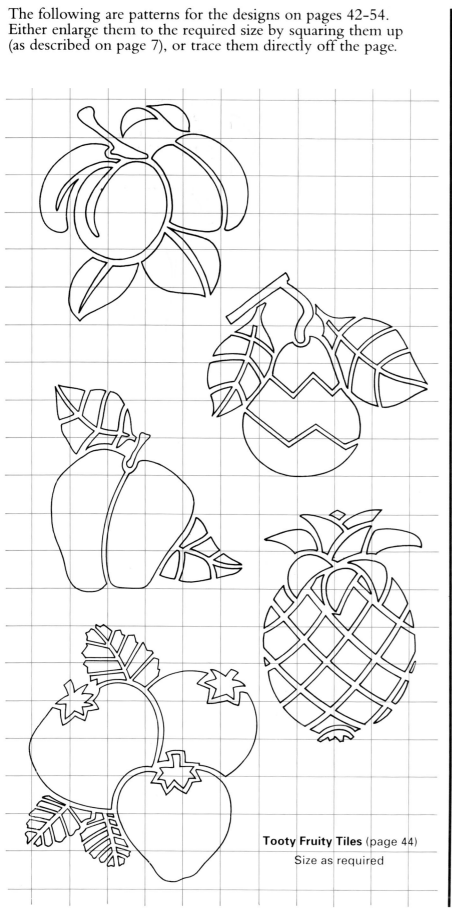

Tooty Fruity Tiles (page 44)

Size as required

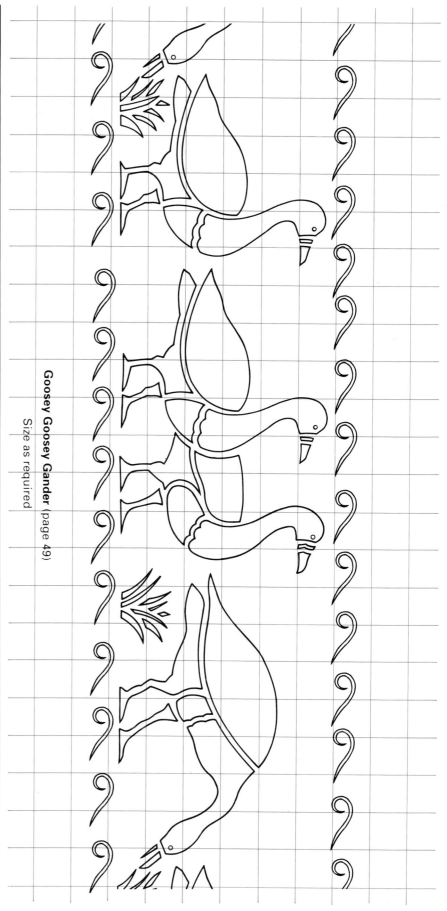

Goosey Goosey Gander (page 49)

Size as required

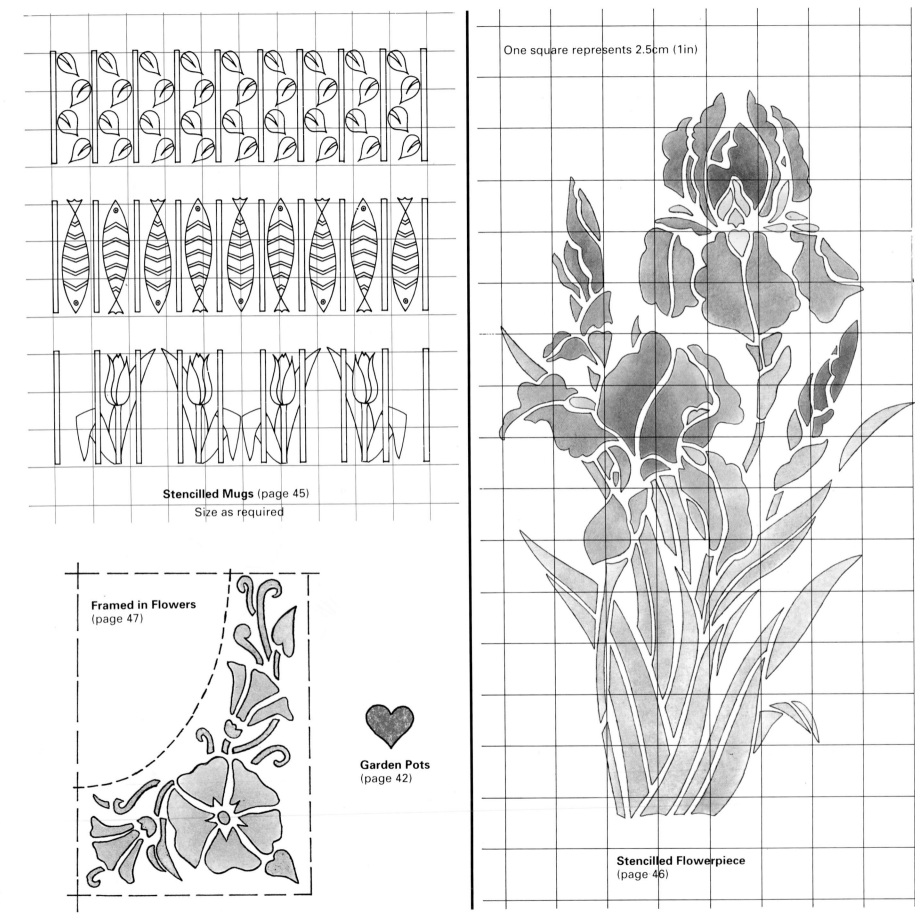

One square represents 2.5cm (1in)

Stencilled Mugs (page 45)

Size as required

Framed in Flowers
(page 47)

Garden Pots
(page 42)

Stencilled Flowerpiece
(page 46)

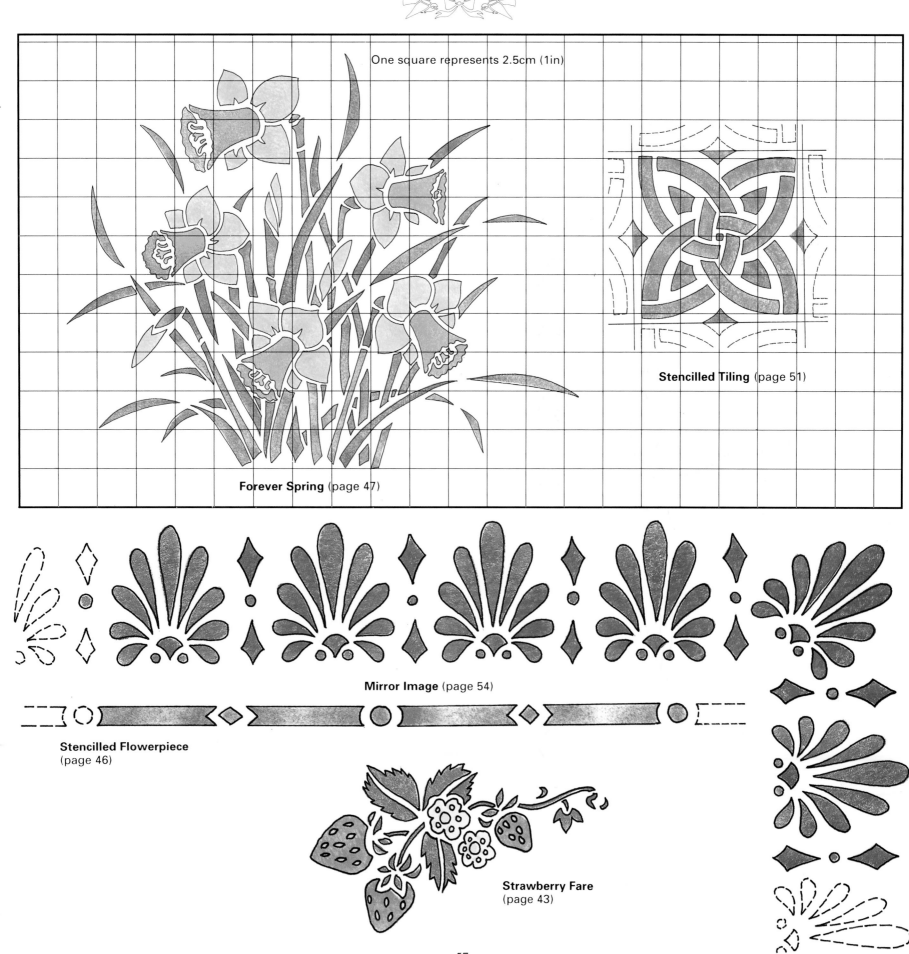

One square represents 2.5cm (1in)

Stencilled Tiling (page 51)

Forever Spring (page 47)

Mirror Image (page 54)

Stencilled Flowerpiece
(page 46)

Strawberry Fare
(page 43)

In this chapter we explore various other decorative painting techniques such as stippling, sponging and ragging shown here, though these need not simply be applied to walls. You can use these techniques to decorate many different items such as china (pages 60 and 62), furniture (page 61) or even gift wrap (page 63). There is also a number of projects using marbling (pages 64-65), potato cut printing (pages 66-67) and masking (pages 70-71 and 73), among others. Remember, each technique can be applied to different objects and often different surfaces to those shown here. So experiment a little!

Stippling is a paint technique which gives an attractive soft finish, made up with a myriad of tiny dots of colour. The wall below is stippled with emulsion paint in two shades of blue — forget-me-not and moon shadow — on a lavender white base. Begin by applying the base colour with a roller or brush, giving two coats if necessary.

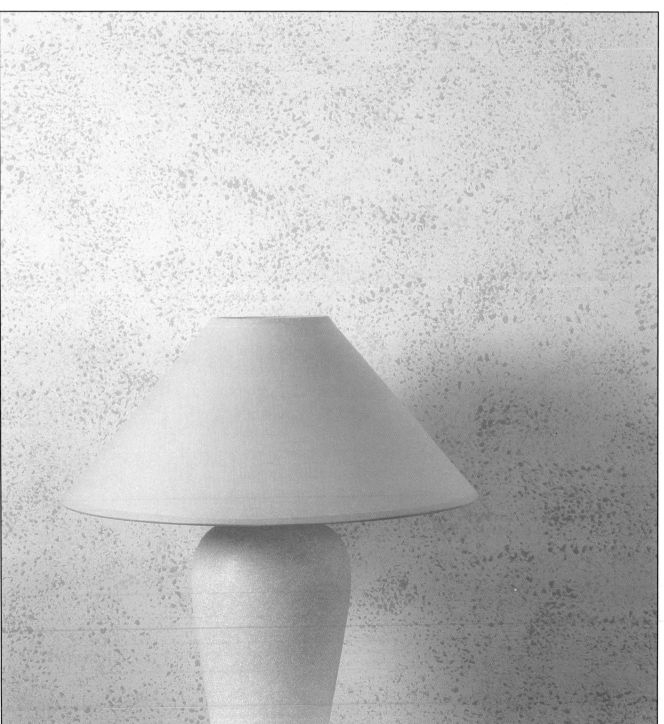

Stippling brushes are wide with a large number of bristles and, traditionally made from badger hair, they are quite expensive to buy. As an alternative you could try using a brush or broom. Lightly dip the brush into your paint so that only the very ends of the bristles are covered. Then apply the paint to the walls with a very light touch so as not to blur the image.

Evenly cover the wall with the first colour, trying not to overlap the stippling. Wash your brush and leave it to dry before applying the second colour as before. Fill in any spaces and overlap the previously stippled areas. Before you take on a whole room, experiment on one small area first to perfect your technique.

RAGGING

There are two main methods of ragging: 'ragging off', in which you apply rags to a wet wall of paint, so removing the colour and leaving a pattern; or 'ragging on' as shown here. In the latter, the colour is applied with bunched-up rags, in a similar way to sponging. First apply a base coat of emulsion paint with a roller or a brush.

Use dry rags for this technique — it is the crisp folds in the fabric that form the pattern. Make sure you cut up lots of rags before you start and have plenty of waste paper around. Clasp a rag in your hand and dip it lightly into the paint. Dab off the top layer of paint on to some waste paper, then apply the cloth to the wall with a dabbing motion.

Continue to apply paint in a random pattern, replacing the rag with a fresh one as soon as it becomes too damp. When the first colour has dried, apply a second colour as before: a contrasting colour can look particularly effective.

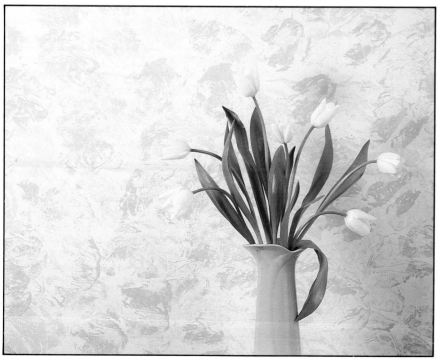

SPONGING

Sponging is one of the easiest paint finishes to achieve. You can use one, two or more colours. When choosing colours, go for a light, mid and darker shade of the same colour. Here, rose white has been used as a base for soft peach and dusky apricot. It is a good idea to buy some small samples of emulsion paint to practise with before you start. First, apply the base coat with a brush or roller.

When your base colour is dry, take a natural sponge and dampen it. Now dip the sponge into the second colour, being careful not to overload it with paint. Remove any excess paint by dabbing the sponge on to waste paper, then apply paint to the walls with a light dabbing motion. Don't press hard or the paint will smudge. Continue in a random pattern, re-applying paint to the sponge as necessary.

Wash out your sponge and apply the third colour, overlapping the second colour. When you have finished you should have an even blending of the three colours. If the last colour is too dominant you can soften it by sponging over with some of the base colour.

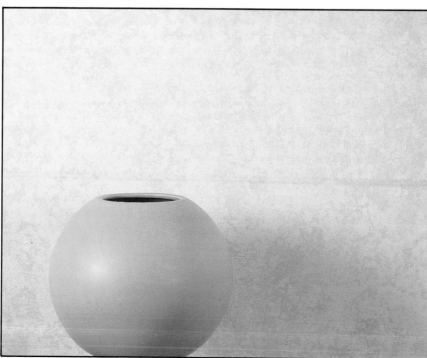

An elegant but inexpensive vase is transformed with the simple use of a sponge and some ceramic paints. Take a small piece of natural sponge and dip it into some white spirit. Squeeze the sponge out and lightly dip it into a saucer of ceramic paint. Dab excess paint on to a piece of waste paper, then apply the colour to the vase with a light dabbing motion.

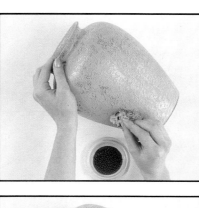

Sponge the whole of the vase, leaving space for a second colour, and re-applying paint to the sponge as necessary. Use a second sponge to apply the next colour, making sure to overlap the colours for an even finish. As an alternative to ceramic paints, you could use high gloss gold lacquer and ordinary emulsion paint.

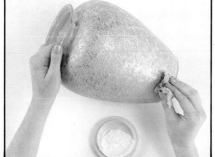

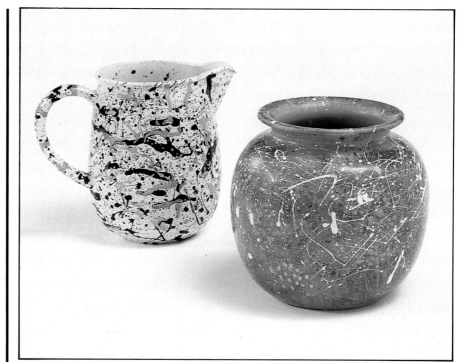

With a combination of ragging and flicking you can transform a plain china vase or jug into a work of art. You will need a piece of cloth for the ragging, a couple of fine artists' brushes and some ceramic paints. Dip the rag into one of the paints and then blot it onto some waste paper to remove any excess paint. Now begin to dab paint on to the vase.

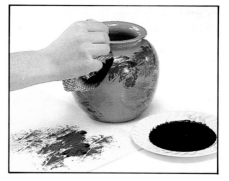

Leave gaps between the dabs of paint to allow the background colour to show through. When you have evenly covered the surface, leave it to dry. Now spatter the vase with white ceramic paint, flicking the paint on with a fine brush. Once again, leave to dry.

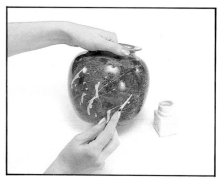

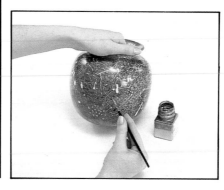

Finally, apply some gold ceramic paint with a fine paint brush, forming clusters of little gold dots across the surface of the vase. Be sure to clear your brush thoroughly in turpentine when you have finished.

SPONGED CABINET

An old piece of utility furniture, long past its prime, is transformed with a beautiful paint finish and some new china handles. Choose a light coloured emulsion paint for the base colour, plus a medium and a dark shade for the sponging on. Before you start to redecorate, you will need to remove the old finish.

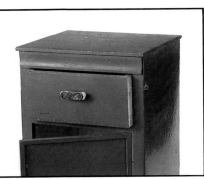

Place the piece of furniture in a well ventilated room, standing it on plenty of newspaper to protect the surrounding floor. Apply paint stripper according to the manufacturer's instructions; leave for the required length of time and then scrape off the old paint. Wash down the surface with liquid detergent and water and, when dry, sand it until the wood is smooth.

Next, apply a primer, an undercoat and then an emulsion base colour, leaving the cupboard to dry between coats. Take a natural sponge, wet it and squeeze it so it is just damp. Dip it into your second colour and dab any excess paint on to waste paper before applying paint to the cupboard. Use a light dabbing motion so that you do not smudge the paint, and leave lots of gaps for the next colour.

Apply the third and darkest colour with a clean sponge, filling in any gaps and overlapping other sponged areas.

Finally, using ceramic paint, decorate some plain white china handles with a pretty leaf or floral pattern. If you need inspiration for your design, try looking at an old china cup or plate.

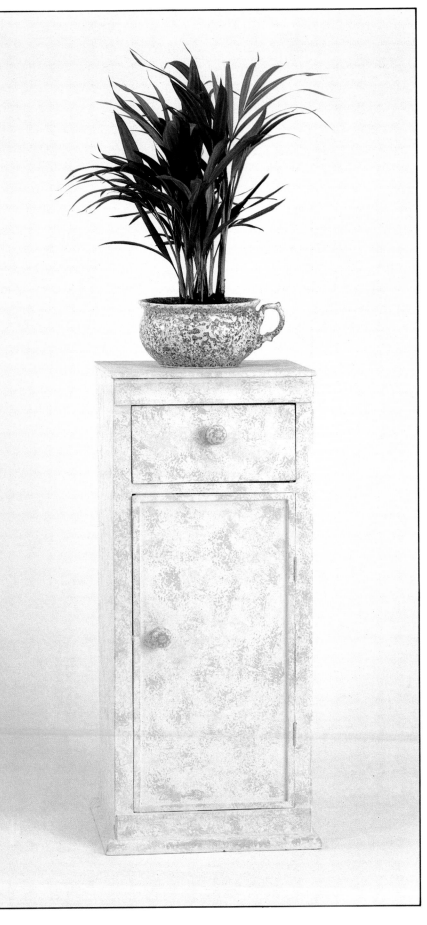

An attractive effect has been created by hand-painting a plain wicker basket to match the colour of the fruit. Paint the basket inside and out with a water-based paint in the background colour, using a small decorating brush. Leave the basket to dry.

Rag-rolling, or ragging, is a quick and easy way to transform a plain fabric or paper tablecloth. Pour a water-based paint or fabric dye onto a plate, and dip a crumpled piece of cloth in it. Blot the cloth on some waste paper or fabric to remove excess paint.

Dip a sponge into a saucer containing the contrasting colour of paint. Dab the sponge a few times on a piece of scrap paper to remove any excess. Then sponge all over the outside of the basket, replenishing your paint supply when necessary.

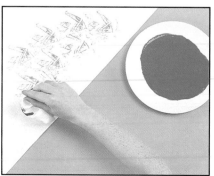

Lightly press the crumpled fabric onto a spare piece of paper or cloth to practice getting an even amount of paint over the area to be covered. Once you feel confident, rag the tablecloth, adding a second colour (once the first has dried) if desired. If using fabric dye, follow the manufacturer's instructions for fixing the colour.

Arrange the fruit in the basket as shown, adding a few leaves for contrast. Clementines are shown here, but apples, bananas and other fruit could be added for variety.

DESIGN WITH A SPONGE

COLOUR-FLECKED PLACEMAT

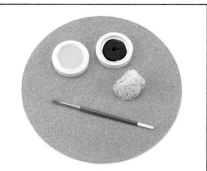

The perfect solution if you can't find tablemats in the right colour – paint your own, using plain cork tablemats and two colours of water-based paint. For applying the paint you will need an artist's paintbrush and a natural sponge.

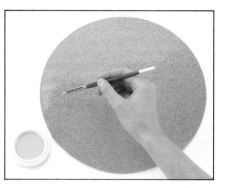

Paint the cork mat all over with the lighter-coloured paint. Allow it to dry. If the colour is very pale you may need to apply a second coat.

Sponging is an ideal way of decorating your own wrapping paper. You'll need a piece of natural sponge as man-made sponge doesn't produce the right effect. Choose some plain paper and mix up some poster paint to a fairly runny consistency. Test the paint on a spare piece of paper until you're happy with the colour.

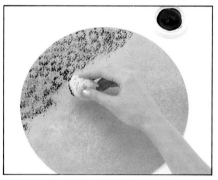

Dip the sponge into a saucer containing the colour; dab it a few times on a piece of scrap paper to remove any excess paint. Sponge the mat all over, allowing the first paint colour to show through. When the paint is dry apply a coat of clear polyurethane varnish for protection.

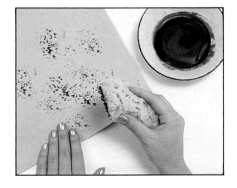

Dab the sponge into the paint and pat it evenly over the paper. The sponge should hold sufficient paint for about four 'dabs' before you need to dip it into the paint again. You'll need to mix up a lot of paint as the sponge absorbs a considerable amount.

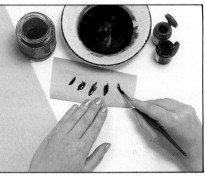

Rinse the sponge out well and squeeze dry. When the paper has dried, repeat the process with another colour – you can use as many colours as you wish. Match the ribbon trim to one of the colours.

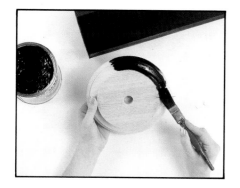

Turn a plain wooden pedestal into a stunning marbled plant stand. Stands such as these are available from craft suppliers (look in craft magazines for stockists). Successful marbling requires a lot of practice, so experiment on a spare piece of wood before tackling the real thing. Prime and undercoat the surface as necessary, then apply a coat of black eggshell paint.

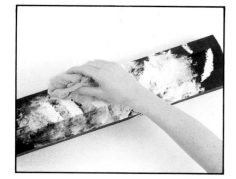

Now mix a white tinted glaze using 60% scumble (available from decorating shops) to 20% white eggshell paint and 20% white spirit. Dab the glaze on to the surface with a decorator's brush, allowing plenty of the black to show through.

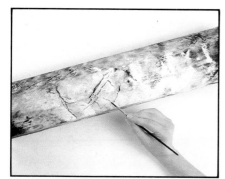

Rag over the wet glaze with a soft cloth, spreading the glaze to give a dappled effect, and still making sure some of the black shows through. Soften the ragging effect with a stippling brush and a rag dipped in white spirit.

Mix a small quantity of black glaze using the same proportions as before: 60% scumble; 20% black eggshell paint; 20% white spirit. Now use a fine pointed brush to paint on the black veining.

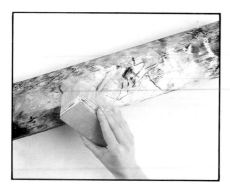

As you finish veining an area, soften the effect with a stippling brush to break up the hard edges. When you have completed the black veining, repeat the process with white glaze, using a stippling brush to soften the edges as before. When the paint is dry, apply a coat of polyurethane varnish to give the glossy cold sheen of marble.

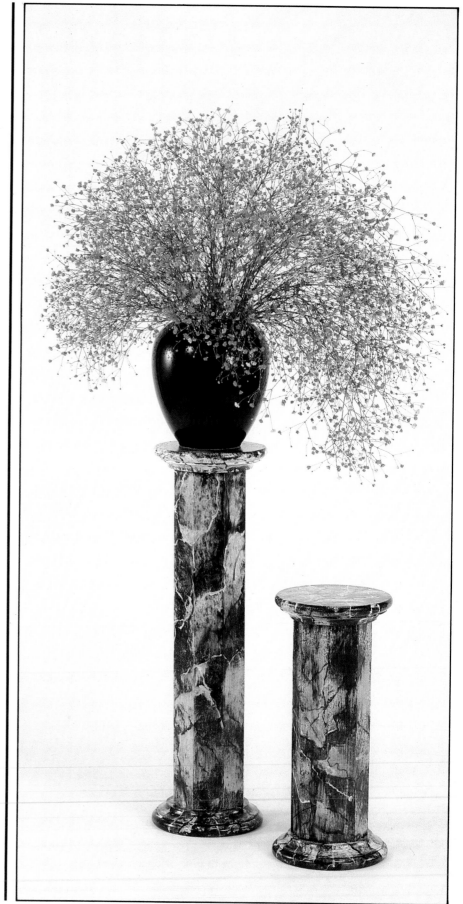

MARBLED GIFT BOXES

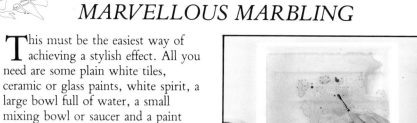

This must be the easiest way of achieving a stylish effect. All you need are some plain white tiles, ceramic or glass paints, white spirit, a large bowl full of water, a small mixing bowl or saucer and a paint brush. You may also wish to wear rubber gloves to protect your hands. Thin some paint with white spirit and begin to drop it on to the surface of the water with a paint brush.

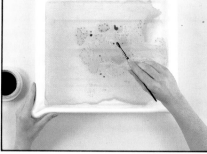

Using the handle of the paint brush or an old stick, mix the colour round so that it creates a swirling pattern. If you wish, you can dilute a second colour in the same way and add this to the first.

Gift wrapping can prove so expensive these days, so why not make your own gift boxes? Here, some plain cardboard boxes have been covered in hand-marbled paper. Fill a large bowl with water, then mix some solvent-based paint such as ceramic paint, or some artist's oil colours, with a little white spirit. Use a paint brush to drop successive colours on to the surface of the water.

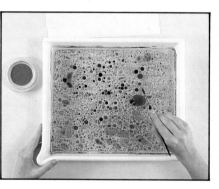

Stir the mixture with the handle of your paint brush or an old stick until you have a pleasant swirling pattern. An alternative way to form a pattern is to blow the paint across the surface of the water.

Carefully hold the glazed side of the tile against the surface of the water and then quickly lift it away. The tile will pick up the swirls of paint to give a marbled effect. Leave the tile to dry then give it a coat of ceramic varnish to protect the finish. You may find it necessary to practise this technique for a while before you perfect it.

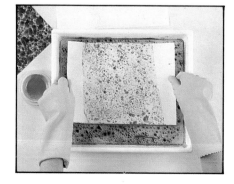

Wearing rubber gloves to protect your hands, put the paper on to the surface of the water, then lift it off immediately. The swirls of paint on the paper will create a marbled effect. When the paper is dry, neatly cover a small box, carefully folding the paper round the corners and sticking it down with glue or double-sided tape.

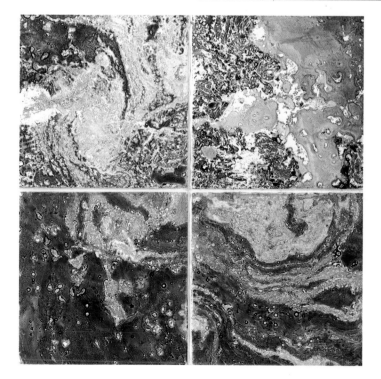

POTATO PRINT GIFTWRAP POTATO PRINT CUSHIONS

Employ a humble potato to create simple yet beautiful designs on giftwraps. Begin by cutting a large potato in half and draw a simple design on it. Use a sharp knife or craft knife to sculp the potato, leaving the design raised from the surface.

Potato printing can be used to great effect when decorating soft furnishings for the home. Cut a potato in half and draw the design on to one half with a felt-tip pen. Now cut around the motif so that the design stands proud of the background.

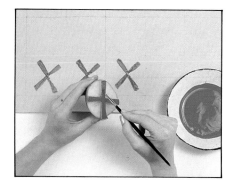

To ensure a regular print, draw a grid lightly in pencil on a sheet of plain paper. Then mix up fairly thick poster paint and apply it to the potato-cut with a paintbrush. Print the design in the middle of each square of the grid. You should be able to do two or three prints before the colour fades and needs replenishing.

Paint some fabric paint on to the potato motif with a brush. Stamp off any excess paint on to some waste paper then print the motif on to your chosen fabric, leaving plenty of space for a second and even a third motif.

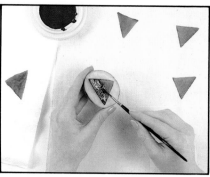

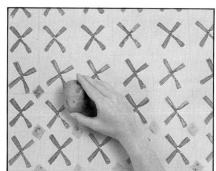

Cover the whole sheet with one design. Cut another design on another potato half; repeat the whole process, this time printing on the cross of the grid. When the paint is thoroughly dry, rub out the grid lines still visible and wrap up your present.

Cut another simple motif from the other half of the potato. Apply the colour as before and print on to the fabric. When the fabric has dried, iron on the back to fix the paints. Your fabric is now ready to be made up into cushions, curtains, blinds and so forth.

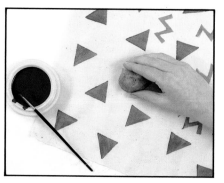

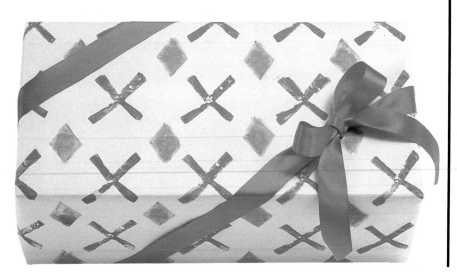

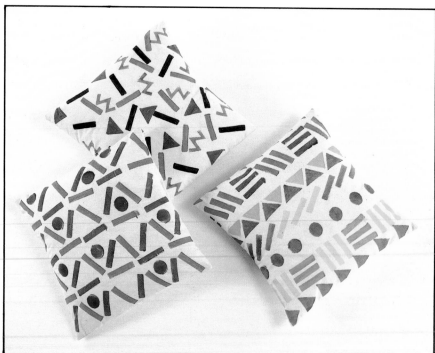

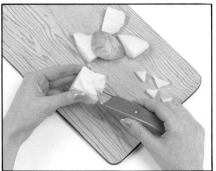

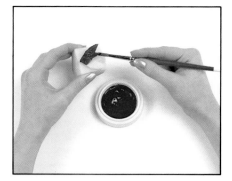

Why not decorate a plain white table cloth with a placemat outline to match your china? Take a raw potato and some paint. First cut the potato into a cube about the size of your chosen motif. The leaf shape shown here is about 3cm (1¼in) square. Using a sharp knife, cut the motif on one side of the cube as shown.

Use a paint suitable for fabric, or a water-based paint if you are printing on a paper tablecloth. Spread the paint evenly over the raised motif.

On a piece of stiff paper, draw the outline of the 'placemat' in black felt-tip pen. Place this under the cloth as a guide when printing. Press the potato down onto the cloth, taking care not to smudge it. Practice first on a spare piece of paper. The same technique can be used to print a border design around the edge of the napkin.

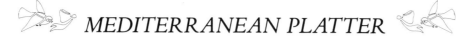
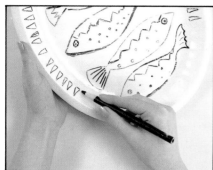

This method of decorating is known as resist painting. To create this primitive design you will need a mixture of glass and ceramic paints. Using a chinagraph pencil, draw the design on to the plate. Remember that whatever areas you cover with the chinagraph will appear white on the finished plate.

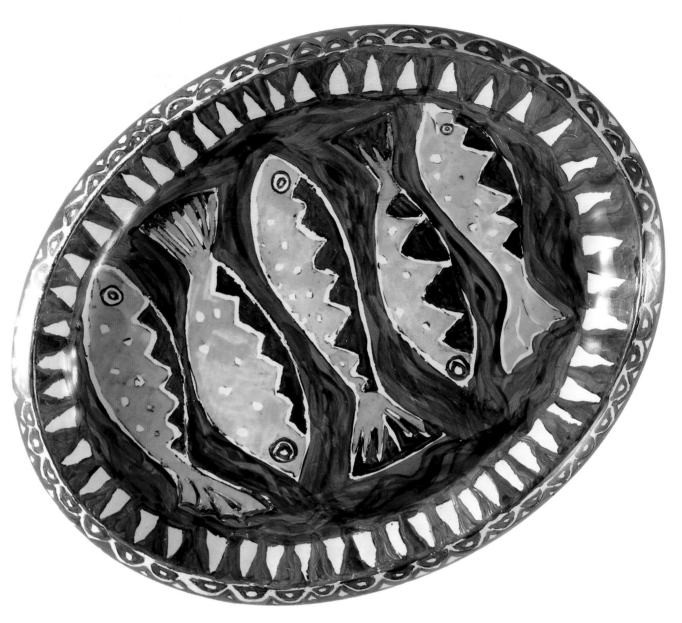

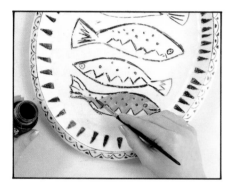

Carefully paint the fish using contrasting ceramic paints. These fish are coloured in deep blue and yellow, but you can try other colour combinations such as purple and orange or black and gold. Now paint the border pattern in bright colours — red looks particularly attractive.

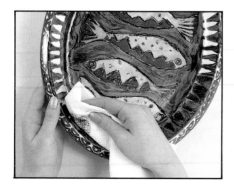

Paint the water surrounding the fish in emerald green glass paint, applying it in an undulating wave pattern to represent water currents. Use glass paint for the water as it is more translucent than ceramic paint. When the paint is completely dry, rub away the chinagraph with a soft dry cloth to reveal the white china.

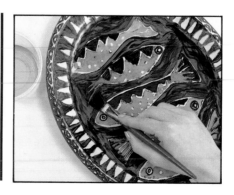

You may need to use a cloth soaked in turpentine to tidy up the edges of the pattern. Finally, protect your design with a coat of ceramic varnish.

EASTER BASKET

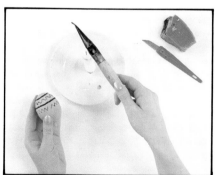

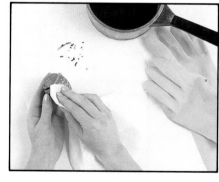

Egg decorating for Easter is particularly popular in Slavonic countries. For this method you must boil the eggs before decorating them. You will need beeswax, some fabric dye, a candle and a tjanting (a Javanese tool designed for painting fine wax lines). Mix the dye according to the maker's instructions. Put a piece of wax in the tjanting and hold it over the candle to melt.

Draw the design on to the egg with your tjanting. Leave the wax to cool before putting the eggs into the dye. (The dye must be completely cold before the eggs are immersed in it.) Check the eggs every few minutes until you are pleased with the colour. Take the egg out of the dye and gently rub off the wax with a cloth. If the wax proves difficult to remove, hold the egg in hot water to melt it.

LEAF PRINT EASTER EGGS

Here's a delightful and unusual way to decorate eggs for Easter Day. As well as eggs, you will need fabric dye, some old fine denier stockings or tights, thread and a varied range of small leaves, the smaller the better. Fill a saucer with water and dip the leaves into the water. Stick the wet leaves on to the eggs (the water will make them adhere).

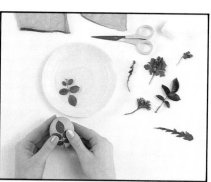

Cut a piece of stocking large enough to more than cover the egg. Wrap it tightly around the egg to hold the leaves in place, and tie the ends securely in a bundle with a piece of thread.

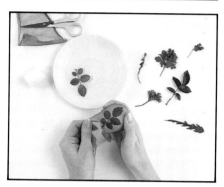

Mix up the dye according to the maker's instructions and place it in an old saucepan to boil. Gently lower the eggs into the saucepan of simmering dye and cook for about 20 minutes. Drain the eggs and put them under a cold tap. Then remove the stocking and leaves; you will find the leaf shapes imprinted on the shells.

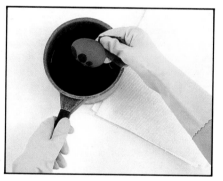

These octagonal glasses look very stylish with a band of colour rotating around the glass. You will need either ceramic or glass paint. Cut four or five strips of masking tape long enough to wind from the top of the glass down to the bottom. Stick the first strip down then add successive strips, leaving a gap between each one.

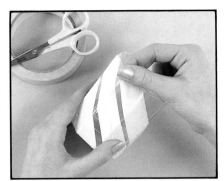

Apply the paint to the exposed areas, holding on to the masking tape while you rotate the glass. Now leave the glass to dry.

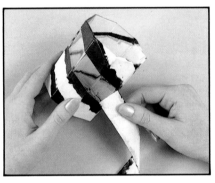

Remove the masking tape. If some of the paint has seeped under the tape, clean it off with a cloth dipped in turpentine.

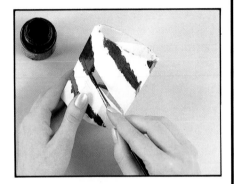

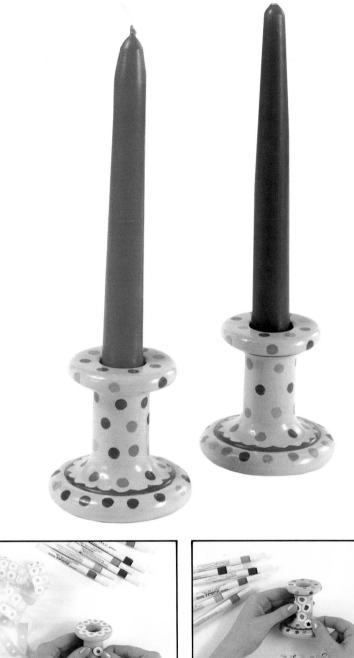

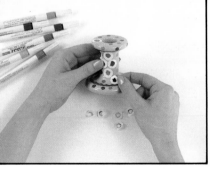

These candlesticks are designed for those in a party mood; they are bright and fun, and especially suitable for a teenage party. You will need some self-adhesive ring reinforcements, candlesticks, and multi-purpose felt tip paint pens in a range of bright colours. Stick the ring reinforcements all over the candlestick as shown.

Paint the centres of the circles in various colours. Once the paint is dry, pull off the reinforcements to reveal a series of coloured dots. Complete the design by painting a border line round the base of the stem in one of the bright colours you have been using. Finally, apply a coat of ceramic varnish.

CURTAINS A LA MODE

These attractive full-length curtains will add style to any modern living room and can be painted in any colour to match the decor. You will need lots of space when painting the fabric so cover your floor with plenty of newspaper before you begin. Now rip sheets and sheets of newspaper into long strips. It is best to use quality newspapers as they are wider and have more pages.

Sew together enough fabric to make a curtain and lay it out on the floor. Tape several strips of newspaper together so that they fit across the width of your fabric. Now, using loops of masking tape on the underside of the paper, stick the strips to the cloth, leaving gaps between the rows. As you work your way towards the top of the cloth, break up the rows with small 'islands' of paper.

Pour some opaque black fabric paint on to a saucer or plate and, starting at the bottom of the cloth, sponge the paint between the rows of newspaper.

With each new row, mix a little white opaque fabric paint into the black before you dip the sponge in. Keep adding white with each successive row so that the colour gradually changes from black to grey as you print up the cloth. By the time you get to the top where you have the islands of paper the colour should be light grey.

Leave the fabric paint to dry before removing the paper. Repeat the whole procedure with the second curtain. Iron on the back of each piece of fabric to fix the colour and then make them up into curtains.

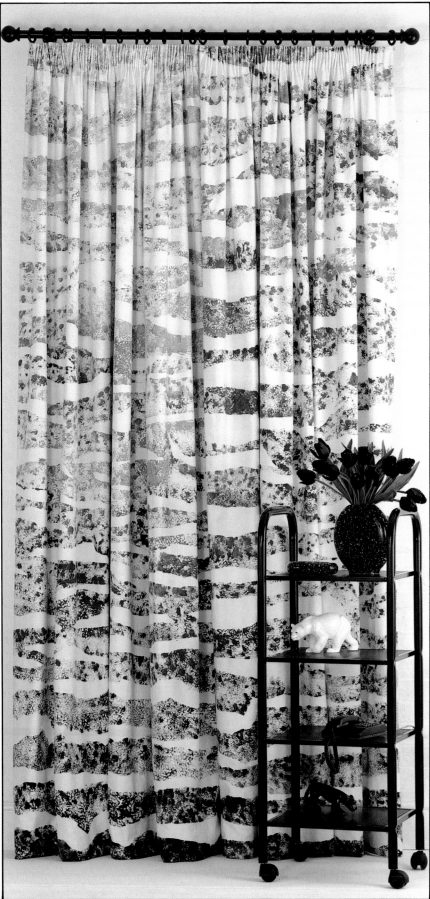

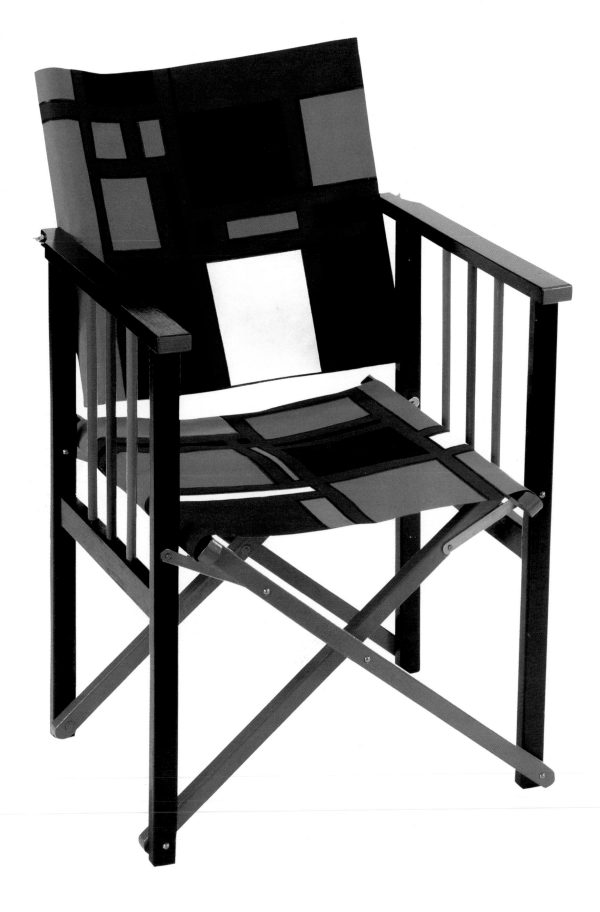

A striking 'Mondrian' inspired design in bold colours gives a new lease of life to a battered old director's chair. Even if you don't have an old chair to do up it's still worth buying a new one to customize. As well as paint brushes masking tape and a sponge, you will also require varnish, acrylic paints, opaque fabric paints and a black fabric paint pen.

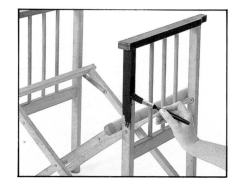

Remove the canvas from your chair; if it is old, you can replace it later with new deck chair canvas. Sand down the chair frame until the wood is smooth and fill any cracks with wood filler. Now paint the outline of the frame with black acrylic paint, applying a second coat if necessary.

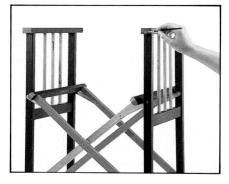

Using red, green and blue acrylic paint and a fine paint brush, paint the cross pieces, the central dowels and the ends of the legs and arms in alternating bright colours. Acrylic paints dry very quickly so clean your brush instantly between each colour.

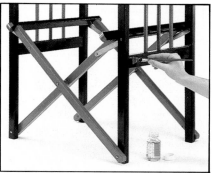

When the paint is completely dry, give the frame a couple of coats of varnish to protect it. Leave the first coat to dry before applying the second one.

Using either the original covers or some new fabric cut to size, put strips of masking tape across the canvas, masking off a series of rectangles both large and small. Rub the tape down with the back of a spoon to give it extra adhesion.

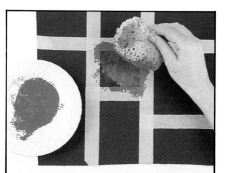

Pour some opaque fabric paint into a saucer and dip a sponge into the colour. Dab the paint on to a masked area of the canvas being sure not to get any paint on the adjacent squares. Use a sponge rather than a paint brush to avoid brush strokes. When you have finished applying one colour, take a clean sponge and apply the nest. Continue like this until all the rectangles are filled in.

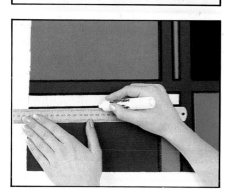

You may find you have to use more than one coat of paint if you are working on a very dark background. When the paint is completely dry, tear off all the masking tape. Finish by drawing a black rule round each of the rectangles, using a fabric paint pen. You can now put the canvas back on the chair.

Create a stunning design on ceramics by masking off areas with torn tape. Cut a strip of masking tape the width of your plate and very carefully rip it in half lengthways, creating an uneven edge. Place the two torn pieces back to back across the centre of the plate. Then add further double strips of tape either side, leaving gaps in between each set.

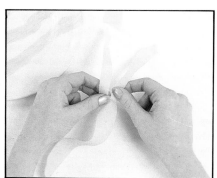

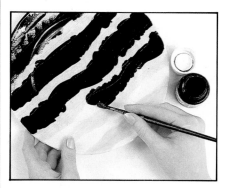

When you have covered the plate in torn tape lines, make sure that all the edges are stuck down properly. Apply ceramic paint to the exposed areas, using a dabbing motion so that the paint does not seep under the tape.

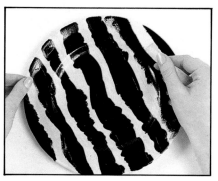

Leave the plate to dry for at least 24 hours before carefully removing the tape. Clean up any smudged edges using a rag dipped in white spirit, then apply a coat of ceramic varnish. The black lines on a white background gives a striking 'zebra stripe' effect, but other colour combinations look equally attractive, so try experimenting a little.

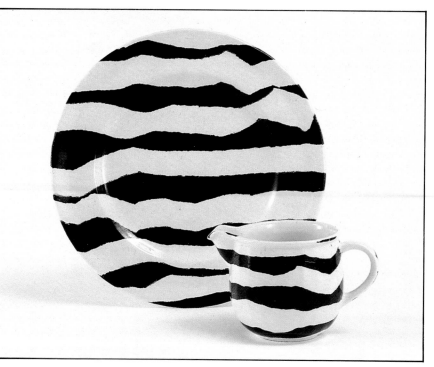

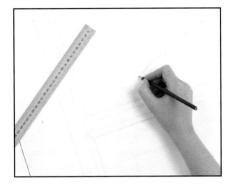

Create a beautiful landscape from your window using a range of paint techniques, from masking and sponging to potato cut printing. Size up the design opposite and lay your roller blind over it, holding it in place with masking tape. Lightly pencil in the main features such as the window frame, garden and cat.

Remove the tape holding the pattern, then mask off the outer edge of the window frame. Dab the surrounding area with a moist sponge dipped in paint.

When the paint is dry, mask around the window frame. Mix some paints with acrylic medium to make the colour of stripped pine. Using a dry oil painting brush, paint the window frame, dragging the paint in lines to resemble wood grain. Next, mask around and paint other areas – such as the sky, hills and lake.

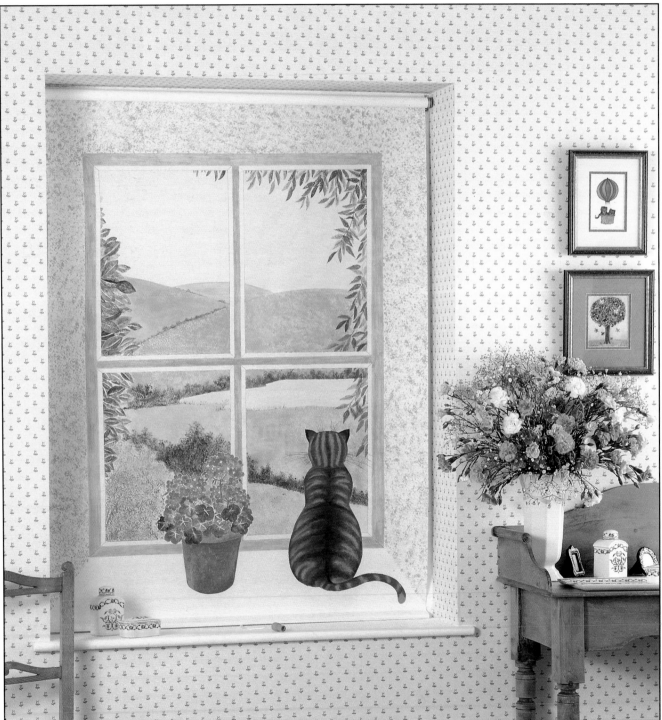

To print the foliage, first cut a potato in half and dry the surface. Using a cardboard template made from one of the leaf shapes shown opposite, trace a leaf on to the cut surface of the potato. Cut vertically into the potato, following this outline, then cut away the excess potato from the edges to leave a flat raised leaf shape.

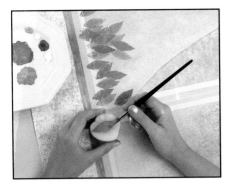

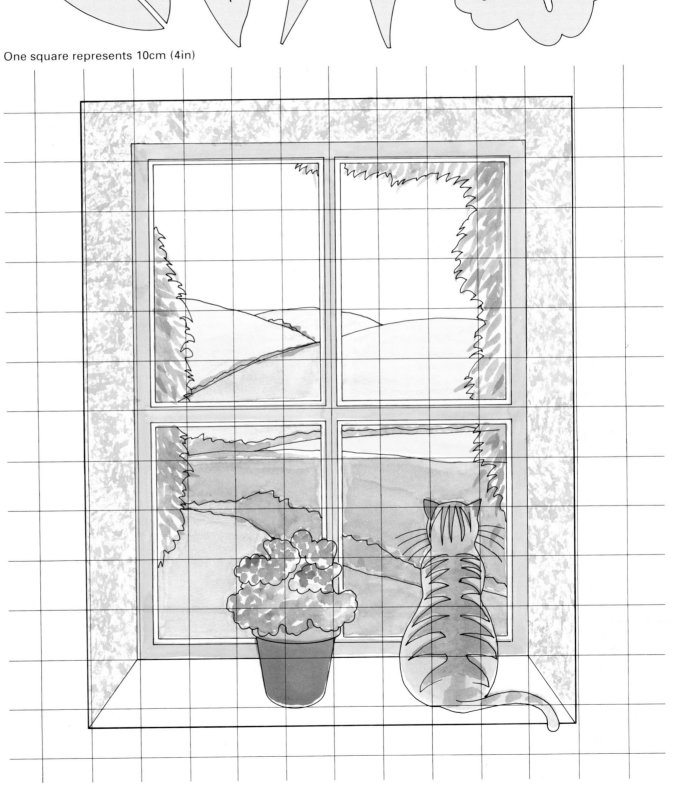

One square represents 10cm (4in)

Mask off the painted window frame with several widths of tape. Mix up a soft green colour and paint some on to the leaf shape, then press the potato cut on to the blind. Continue to print leaves, using a range of greens and overlapping the shapes to give a natural effect. Then use a fine brush to paint the leaf stems.

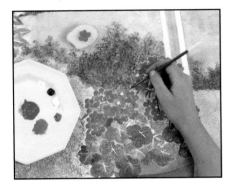

Make some geranium flower and leaf potato cuts in the same way and use them to print the geranium plant. Also paint a few buds and stems using a brush. When this is dry, mask and paint the pot in shades of terracotta using a larger brush. Finally, mask and paint the cat, finishing off with a fine set of whiskers.

Trace the leaves and flowers directly from the page and turn the shapes into cardboard templates.

Now is the time to really display your artistic talent! Most of the following designs demand freehand drawing or painting using a number of materials: acrylic, glass and ceramic paints, felt tip pens, fabric paints or crayons, or even colours for silk. For more complex projects we have provided templates, but you can of course design and draw your own. The principle objective of this chapter is to demonstrate just how individual and creative you can be: whether it is in the choice of paint or colours you use, the finish you apply (see our crazed 'antique' glaze on page 77), or what you choose to decorate: boxer shorts (page 87), glassware (page 93) or a silk scarf (page 86).

Made in the Phillipines from balsa wood, these lovely ornamental ducks are exported all over the world and are widely available in department stores. They are ideal for painting and, as you can see, the end results can be quite stunning. Draw your design on to the duck in pencil, either following one of the designs shown here or using a bird book as reference. Now start to paint.

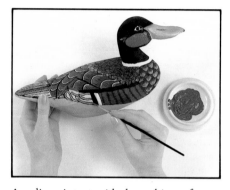

Acrylic paints are ideal on this surface but you can also use glass or ceramic paints, or even a mixture of all three. Paint the main areas of colour first and then change to a finer brush and fill in details such as the eyes, the white ring round the neck and the markings on the wings and tail.

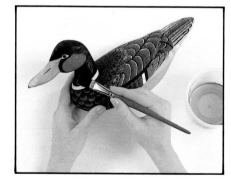

Finish off with a coat of polyurethane gloss varnish. If you have used a variety of paints remember that they will dry at different rates so make sure they are all dry before varnishing.

HARVEST STORAGE JARS

B ring the countryside into your kitchen with these charming storage jars. Cut out a piece of paper to fit round the side of the jar and draw your design on to it. To work out your colour scheme, colour the design using felt tip pens. Trace off the design on to the jar and outline the pencil with a fine black felt tip pen.

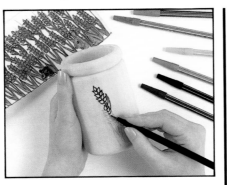

Colour the corn with the coloured felt tip pens, leaving the middle of some of the husks the natural wood colour so that the corn looks more rounded and realistic. Paint the centre of some of the other husks yellow to add more interest. Do not press the pens too hard as the colour will bleed.

Colour in the animals and butterflies and decorate around the top edge of the jar with green, as shown in the main picture, to suggest hills. Paint the lid with swallows soaring in the sunshine and, when the inks are dry, finish with a coat of polyurethane varnish to protect the colour.

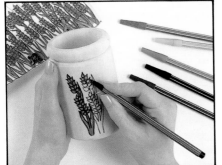

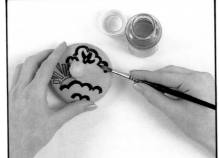

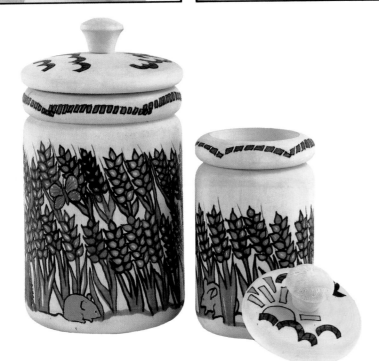

PEACOCK SALT BOX

C rackle varnish creates an interesting 'antique' finish on a prettily decorated wooden salt box. Such boxes can be purchased from specialist craft suppliers at little cost (look in craft magazines for stockists). First, draw your design in pencil on to the pieces of the box. Go over the pencil marks using a fine paint brush and black acrylic paint.

Now fill in the design using brightly coloured acrylic paints, mixing and diluting them with a little water if necessary. Leave the paints to dry thoroughly before pinning the box pieces together.

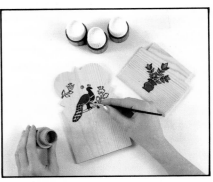

Cover the box with a coat of patina varnish and leave it to dry for between 4-12 hours before applying a second coat. Once the second coat is dry to the touch (rather than completely dry, paint on a coat of crackle varnish. This should crackle in 15-20 minutes, leaving the box with a crazed, old appearance.

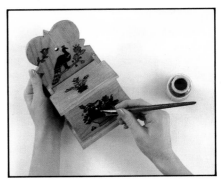

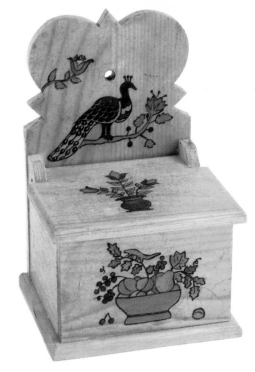

The frame you put a picture in can be as important as the picture itself. Frames can be expensive so it's worthwhile spending a little time renovating old ones. The small frame here was new but very plain. The black one needed repainting, with new gilt edging, and the third frame needed filling.

The design inspiration for the small frame was papier mâché frames and boxes made in India. Give the frame a coat of black ceramic paint and then leave it to dry. Now paint the floral design using a gold multi-purpose felt tip paint pen.

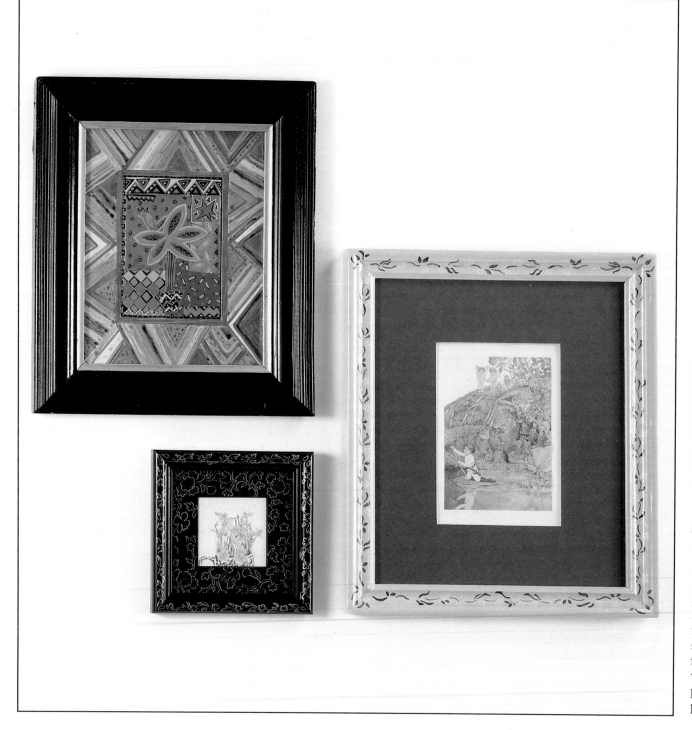

Apply a coat of black paint to the mount also. Paint the floral design in gold as before, completely covering the mount, and finish off by filling in the design with deep blue acrylic paint.

The large frame with the gold edge was simply repainted in black ceramic paint and the edge was outlined in gold. A new cardboard mount was cut and painted with silk paints and a gold felt tip pen, providing a very colourful surround to the picture. The final frame was filled at the joints with wood filler and sanded down, then painted to match the flowers in the picture it holds.

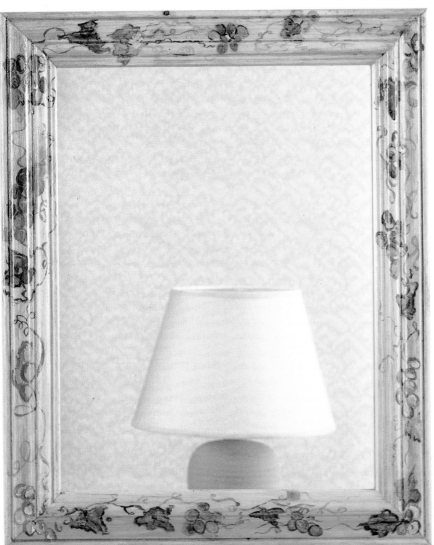

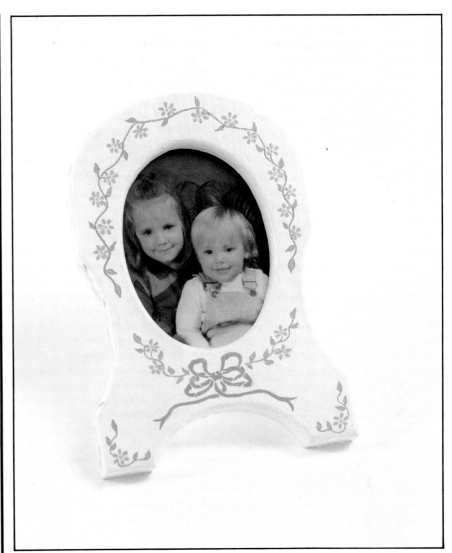

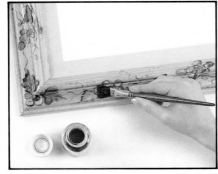

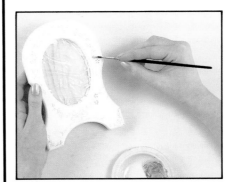

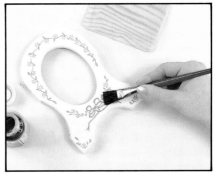

A vine leaf desgn is used to enhance a plain mirror frame. The design can be painted with acrylic or a combination of ceramic and glass paints, using different shades of green, plus brown, white, yellow and black. Protect the glass before you start painting with a layer of paper stuck down around the edges with masking tape.

To age the frame stain it with brown and green glass paint diluted with turpentine. When the stain is dry, finish with a coat of varinish . Another way of ageing the frame is to use the 'crackle' varnish method as described on page 77.

This pretty little frame is perfect for standing on a dressing table. Firstly, sand the frame until it is smooth and then give it a coat of white acrylic paint. Apply a second coat of paint if necessary and, when dry, draw the design with a soft pencil. Paint the design using acrylic paint in soft blues and greys with the flower centres in bright yellow.

Remove the backing and the glass and give the frame a protective coat of polyurethane varnish.

Personalize a pine toy chest with your child's name and a delightful array of wild animals. You will find a template of the design on page 94; all you have to do is add the name. Using wire wool and white spirit, remove any wax finish from the box. Wipe the chest down with clean soapy water and, when dry, sand down any rough edges.

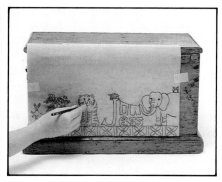

Draw the design on to tracing paper, then go over the back of the trace with a pencil. Now tape the design on to the box and trace over the original line. This will only leave a faint mark unless the wood is new, so go over the lines with a pencil or even a fine felt tip pen.

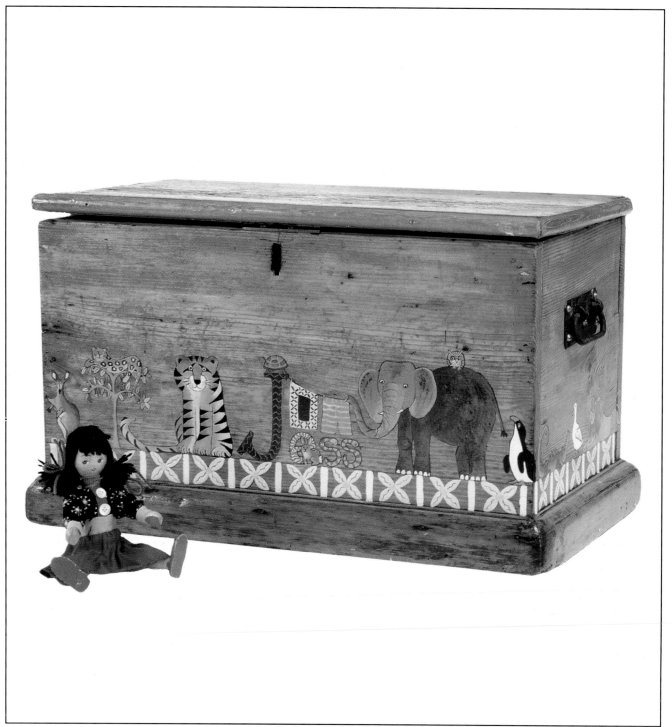

Using acrylic paints, start painting in the design. An old plate or saucer wil serve as a palate on which to mix your paints. Try to add tonal variation with light and dark shades, but if you are not happy doing this, keep the colours flat.

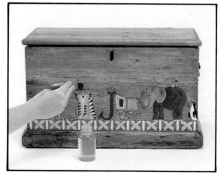

When the paint is dry you can strengthen the outlines by drawing round them once more with a pencil or fine felt tip pen. Use a pen or pencil to add fine details such as whiskers, eyes and mouths as well. Finally, give the box a coat of clear varnish. This will not only protect the design but will also make the colours come to life.

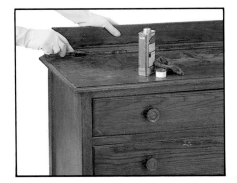

An old chest of drawers is stripped down and given new life with a beautiful rose motif. The idea works just as effectively on modern pine furniture. If necessary, strip off the old finish with varnish remover or paint stripper, according to the manufacturer's instructions. Use an old toothbrush to get into difficult corners. Rub the wood down with wire wool and then sand it until it is smooth.

Draw the design on to tracing paper, referring to the template on page 94. Draw variations on this design for the back plate and centre drawer. Either trace the design on to the furniture or cut it out and draw round the shape, filling in the detail afterwards.

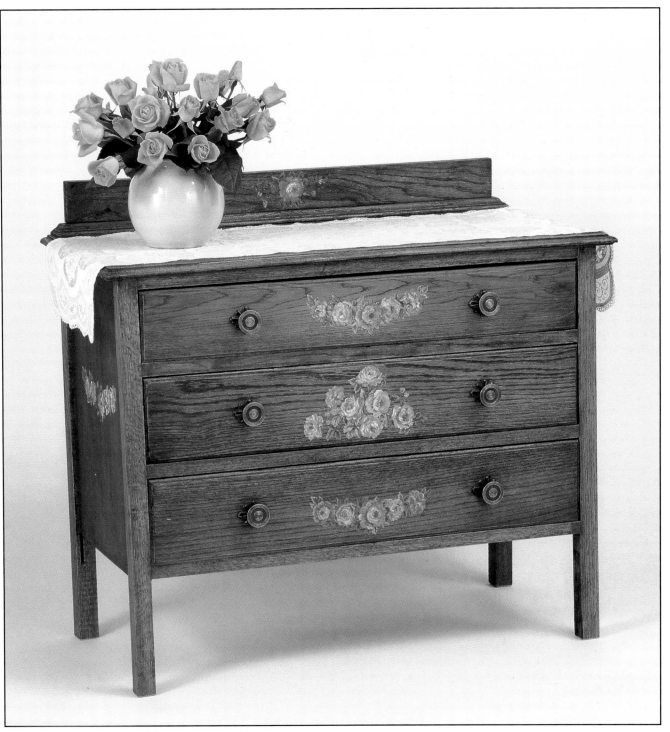

Start to paint the design with acrylic paints, mixing the colours well so that you have a wide range of shades and tones. Use darker shades to create shadow and depth, and light shades, including a touch of white, to add highlights.

When your design is finished and completely dry, apply a coat of varnish to the rose motifs. You can then wax the woodwork, applying several coats of beeswax polish to build up a good finish. Alternatively, you can save your energy by varnishing the entire chest.

FLORAL LLOYD LOOM

BAMBOO STOOL

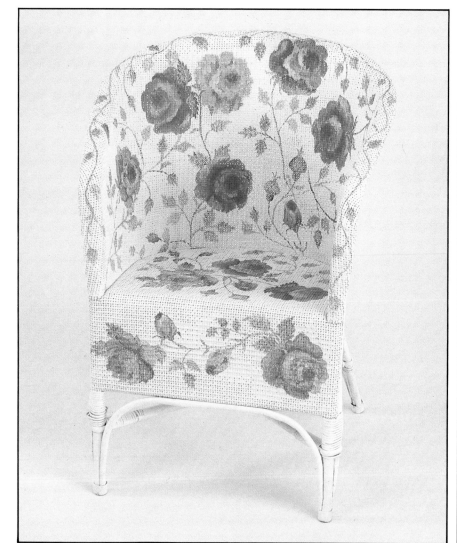

Bambooing is a simple but effective paint technique which can add interest to a plain piece of cane furniture. Before you start to paint, remove any varnish from your furniture with varnish remover. Dilute some brown acrylic paint with water to make a wash, then, using a 20mm (¾in) brush, paint bands of colour at intervals along the cane.

Next, using the same colour undiluted and a fine brush, paint on the markings. First, paint lines of colour in the centre of the band of wash. Next paint elongated 'V' shapes in pairs at right angles to the lines, finishing off with tiny dots by the sides of the Vs. When the bambooing is complete, apply a coat of varnish to protect the paintwork.

In recent years, Lloyd loom chairs such as this have become collectors' items. But because so many of them are now in poor condition, they are often renovated and painted with an attractive motif. The flamboyance of this design is intended to reflect the warm sunny conservatory for which such chairs were originally intended.

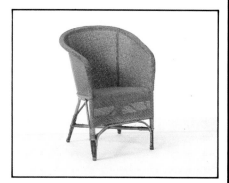

You can either paint the chair using aerosol spray paint or apply paint in the traditional manner with a paint brush. Draw your rose design on to the chair, using a soft pencil and keeping the flowers big and bold. Colour in the design with acrylic paints, mixing the colours to get a wide range of shades. Use dark shades to add shadow and depth, and lighter shades for the highlights.

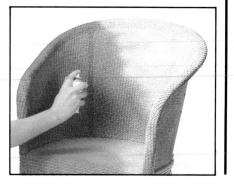

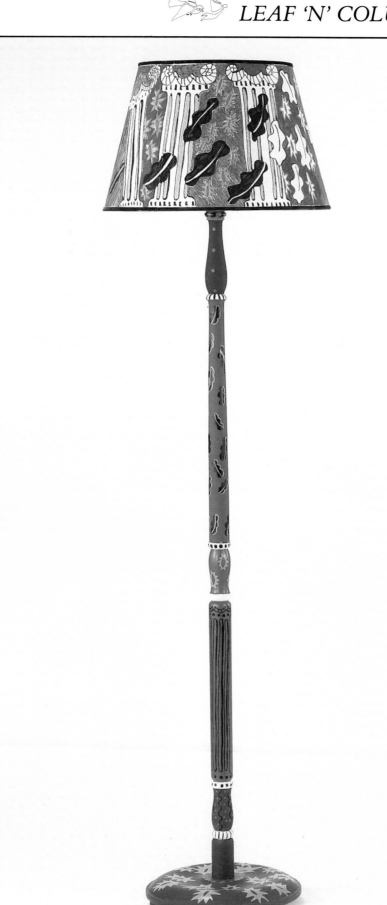

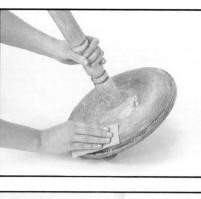

Here's something for those who enjoy the outrageous and the avant garde — an old standard lamp eye-catchingly decorated with Doric columns and oak leaves. Following the maker's instructions, strip the original finish off the lamp-stand with varnish remover. Use an old toothbrush to get into difficult corners. Rub down the surface with wire wool then sand it to give a smooth finish.

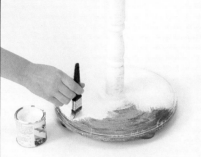

Paint the stand with primer and, when this is dry, apply some undercoat. Alternatively, you could use two coats of combined primer/undercoat. Leave the stand to dry before you begin to apply the colour.

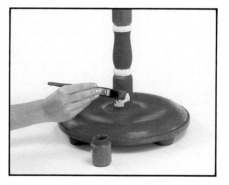

Decorate the standard lamp with acrylic paints, using bold, primary colours. Paint different parts of the lamp different colours, and break the colours up with rings of white, using the carved features as guidelines.

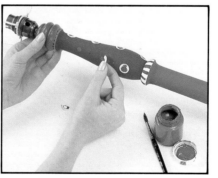

Now decorate the base colours with dots, dashes, spots, leaves and columns, using both acrylic paints and multi-purpose felt tip paint pens. Paint the spots by sticking ring reinforcements on to one section of the stand and filling in the holes with a brightly contrasting colour. Paint black oak leaves on another section and outline them in bright yellow using the felt tip pens.

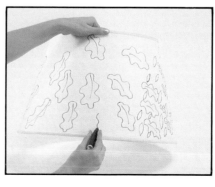

When the stand is dry, apply a coat of protective varnish. Outline your design on the shade with a fine line fabric felt tip pen, repeating the patterns used on the stand. Now fill in the design with thick fabric pens, continuing to use brightly contrasting colours.

CHERRY RIPE

Co-ordinate your kitchen 'wear' with a simple but effective design of cherries. You will need some fabric felt tip pens and/or some opaque fabric paint plus an apron, tea cosy, pot holder and tea towel to decorate.

Practise the design on some paper first, then, when you are confident, use a fine fabric felt tip pen to draw the outline of your design on to the fabric. Here, the leaves and cherries have been spaced out so that they appear to be tumbling down from the tree. On the apron pocket the leaves are grouped to act as a nest for the falling cherries.

Now fill in the outlines with red and green paint. On dark backgrounds you will need to use opaque paints; these are harder to apply than the felt tip pens, so be patient and keep going over the design to achieve the intensity of colour desired.

When the paint is dry, use the black felt tip pen to add veins to the leaves and shading to the cherries. To complete the design, add white highlights to the cherries. This can be done either with a pen or with the opaque fabric paint. Finally, iron the back of the fabric to fix the paints.

'QUILT' CUSHIONS

ABSTRACT TABLECLOTH

These cushions are based on designs taken from American patchwork quilts. With a soft pencil, copy the design on to tracing paper then position the trace, pencil marks down, over your chosen fabric. Transfer the image on to the fabric by tracing over the back of the design.

When the design is on the material, go over it with a pencil if the image is not strong enough. Apply the first colour using a fabric felt tip pen.

Fill in the other colours. If you are using alternate colours, as on these leaves, it is a good idea to mark each leaf with the correct colour so you don't make a mistake half way through. Iron on the back to fix the design and make the fabric up into cushions.

Transform a plain tablecloth with this eyecatching design. Choose a brush the correct size for your design, and use a paint suitable for fabrics. (Because the paint is applied quite thickly, a paper tablecloth is not suitable.)

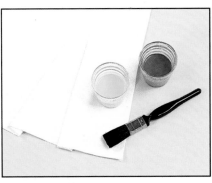

Practice first on a spare piece of cloth or paper, dipping the brush into the paint for each new stroke. Then paint the cloth, applying the lighter colour first; allow it to dry thoroughly.

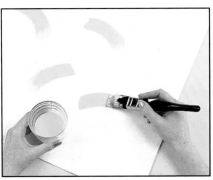

Paint on the second colour in broad sweeps, allowing the paint to fade off towards the end of each brushstroke. Follow the manufacturer's instructions for fixing the fabric paint.

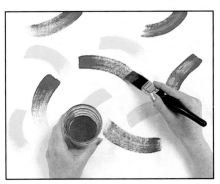

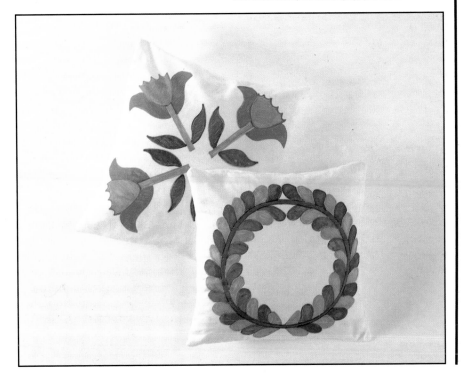

Silk painting is very much easier than it looks and, once hooked, you will find it not only a satisfying hobby but also a wonderful source of presents for friends and family. Either draw the design on page 95 to the required size or trace over a design you wish to copy, such as a picture in a magazine or book.

Using silk pins, stretch your length of silk over a frame. (Easily assembled frames for silk painting are readily available from craft shops.) Tape the design to the frame underneath the silk so that you can see it clearly through the fabric.

Fill an applicator with gutta (see page 6) and trace over the lines of the design, making sure that all the lines are completely joined; any gaps will allow the silk paint to bleed through. Leave the gutta to dry for about an hour before applying the silk colours.

Use a soft brush to apply the paint. Place your colour-loaded brush between the lines of gutta and let the colour creep up to the lines. Rinse the brush in water before using the next colour so that you don't end up with muddy hues. Once you have completed your design and the paints are dry, iron on the back of the silk to fix the colours. Your scarf is now ready to hem.

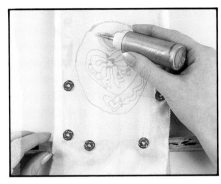
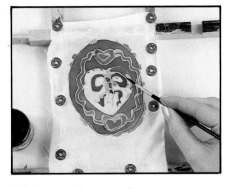

I f you really love someone, you'll want to send him a beautiful Valentine's Day card, hand-crafted by you. To make it easier, you can buy the card blanks in most craft shops or haberdashery departments. The designs here are painted on silk. Stretch a piece of white silk over a frame (available from craft shops) and outline the design with gold gutta (see page 6).

Make sure the gutta lines are continuous so that they can't bleed through once the design is painted on. When the gutta is dry, apply the silk colours with a fine brush. Do not be over generous with the paint as the silk can only take so much before it is saturated and the colours start to bleed.

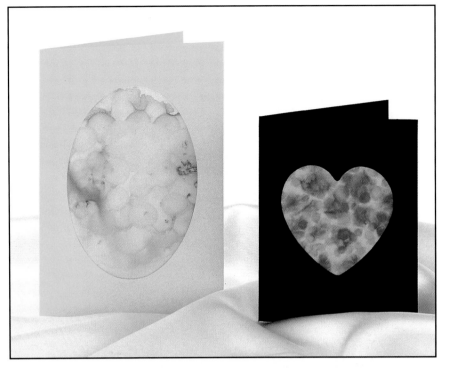

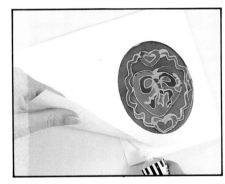

When the silk is dry, fix it according to the paint manufacturer's instructions. Then glue the silk in position on to the blank card and stick the mount down around it.

W onderful abstract patterns can be produced by sprinkling salt on freshly painted silk. Cut a piece of fine white silk lining and place in an embroidery frame, pulling it taut. Select the colours of silk paints you wish to use and wet your brush in a water jar. Apply the paint fairly swiftly and immediately sprinkle on salt. Fill the frame with designs.

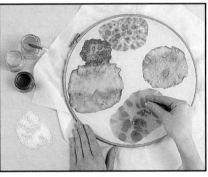

Leave to dry, then brush off the salt. The silk will yield a variety of effects, so place different ready-cut window cards over the most attractive patterns. Mark the area to be framed in the window, then cut out the silk slightly larger. You could also add embroidery, beads and sequins to designs.

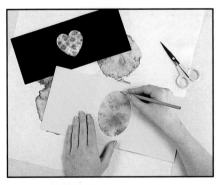

Mount the silk in the centre window of a 3-fold card (available from craft shops) using double-sided tape. Stick down left-hand portion of the card over the back of the silk.

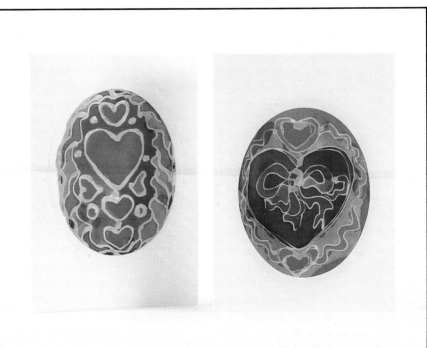

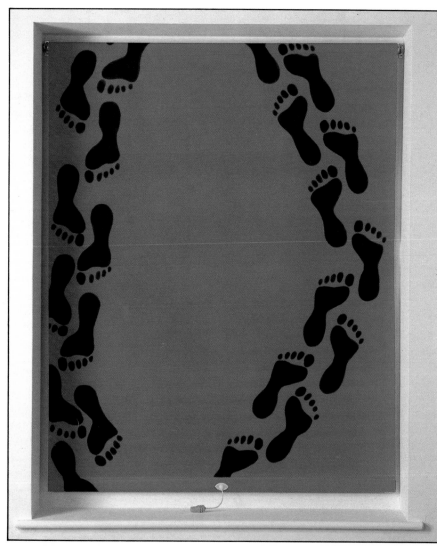

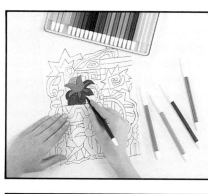

Create a unique gift for the man in your life by decorating a pair of boxer shorts with fabric felt tip pens. Draw your design on to paper first, referring to the template on page 95 if you wish to create this busy design. Work out your colour scheme by colouring in your design with felt tip pens.

Place a piece of card between the front and the back of the shorts to stretch the waist band and stop the paint seeping through. Draw the design on to the fabric using a fine fabric felt tip pen. If you don't feel confident drawing the design straight on in pen, trace it on in pencil first.

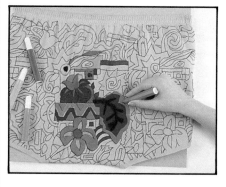

Colour in the design in bright colours, using either fabric felt tip pens or fabric paint and a brush. To fix the paint, iron on the back of the fabric once your design is complete.

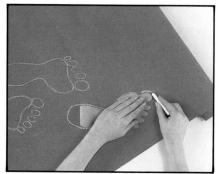

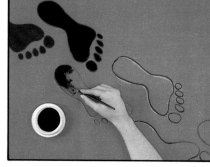

This is a very simple but effective design for a blind. All you need is a plain blind, some chalk, black fabric felt tip pen and your own two feet! Draw round your foot on tracing paper and cut out the shape. Use this as a template to draw feet on to the blind with chalk, drawing the toes individually as shown. Keep turning the template over to get left and right footprints.

When you have chalked your design going up and down the blind, draw over the chalk with a black fabric pen. Fill in the centre of each foot with black fabric paint then iron on the reverse side of the fabric to fix the colour.

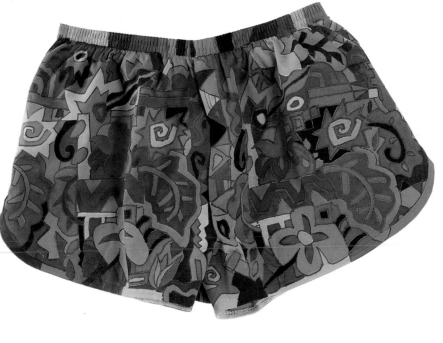

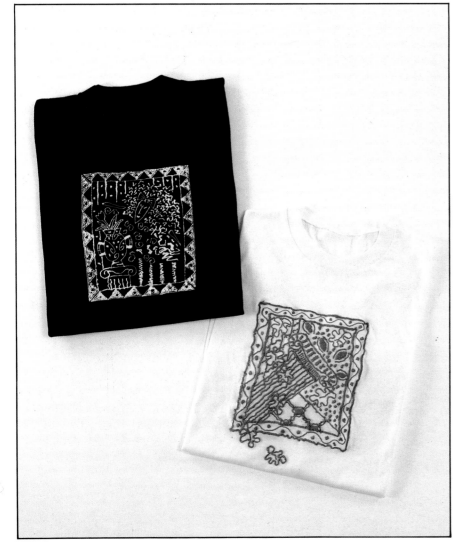

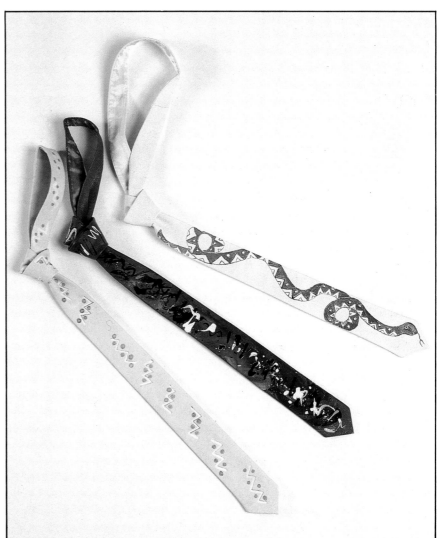

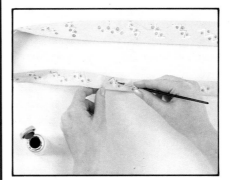

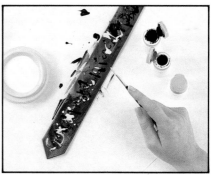

These Grecian-style tee shirts are decorated with a paint that expands upon heating, so that the design is raised above the surface of the fabric. First, draw your design on to a piece of paper. Then stick the design on to a piece of cardboard and stretch the tee shirt over the card, fastening the fabric down with masking tape. Trace the design on to the tee shirt using the 'expanding medium' paint.

Leave the paint to dry for 20 to 30 minutes before fixing it. This can be done by ironing the reverse of the design for 15 seconds (using a silk or wool setting). The other way to set and expand the paint is to use a hair dryer.

Take a leather tie, some opaque leather dyes and plenty of imagination! Leather dyes are simple to use — just paint them on with a fine brush — and you can create any style you wish, from the modest to the outrageous. The pink tie has a simple zig-zag pattern drawn on in white with deep pink spots circled in blue. Be sure to clean the brush thoroughly between each different colour.

To create this tie, sponge the leather with a mixture of blue and black dye. Then use a paint brush to flick white, blue and black leather dyes all over the surface. The white tie has been decorated with a coiled serpent.

Avery easy way of painting tiles is to use multi-purpose felt tip paint pens. Assuming each square represents one tile, square up your design and transfer it on to the tiles using a chinagraph pencil. Draw over this line with a fine line felt tip paint pen. Try to keep the paint flowing once you have put the pen on to the tile so that the line is continuous.

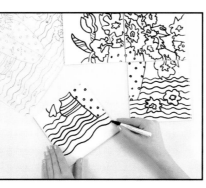

Colour in your design using both thick and fine line pens. Be as outrageous as you like with your use of colours, placing reds, oranges, and pinks together, and adding a sparkle with gold and silver.

Add to the range of tone and colours with plenty of dots and lines in contrasting colours. To finish, protect your design with a coat of ceramic varnish once the paints are dry.

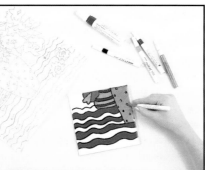

Clowns are a very bright and jolly popular image and, painted on to wall plates like these, they make a colourful decoration for a child's room. Look at birthday cards, wrapping paper, toys and in children's books for inspiration.

Once you have drawn your design on paper, copy it on to a plate using a chinagraph pencil. When drawing your design, consider the shape of the plate; make the feet curl round the edge, as we have done here, and try to make the image fill as much of the plate as possible. Next, follow the chinagraph line with a line of black ceramic paint.

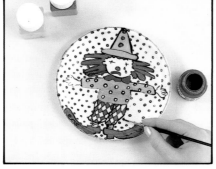

Colour the main features such as clothes and hair using very bright ceramic paints: cherry red, lavender, blue, orange, yellow and green. Make the clothes colourful and busy, with plenty of spots, checks and patches.

Finally, fill in the background with circles, triangles or wavy lines, painted in brightly contrasting colours. When the paint has dried, finish off with a protective coat of ceramic varnish.

Transform a rather plain ceramic honey pot into something striking! Using a fine paint brush and black ceramic paint, paint some bees on to the lid of the pot. If you are worried about painting free-hand, first draw the bees on with a chinagraph pencil. And if you are not even sure how to draw a bee, get a picture of one to copy.

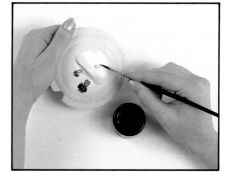

Now paint the stripes with black ceramic paint. If, like this one, your pot is ridged, use the raised surface as a guide for your lines of paint. Otherwise you can use strips of masking tape to mask off those areas which are to be yellow. In order not to smudge the work, you may find it easier to paint the lower half first and then leave it to dry before painting the top half.

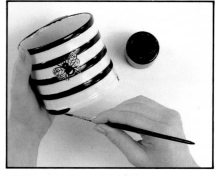

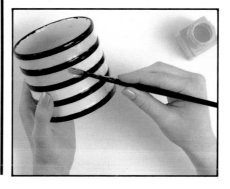

When all the black has dried, apply the yellow ceramic paint, carefully filling in the bee's striped body with a fine brush. Fill the pot with honey and have a nice breakfast!

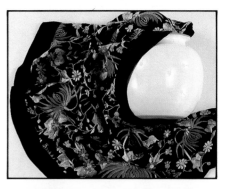

The inspiration for this vase comes from a beautiful piece of Victorian embroidery. The designs are similar except the white and black have been reversed so, instead of white stalks on a black background, there are black stalks on a white background. You can either copy this design, or find a similar piece of embroidery to copy.

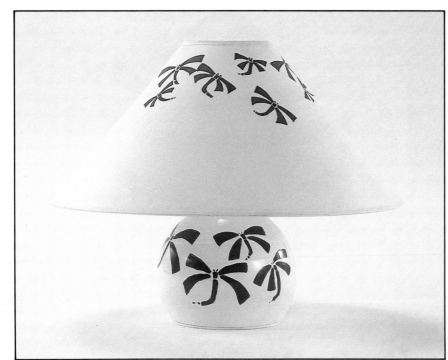

As it is always difficult to paint directly on to a curved surface, first draw the design on to the vase using a chinagraph pencil.

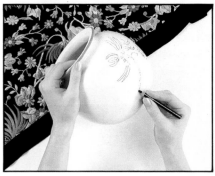

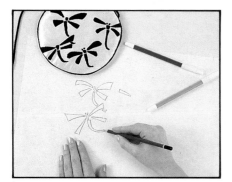

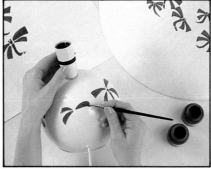

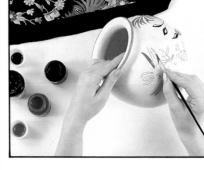

Colour in the design with ceramic paints, mixing the various colours together to get the right shades. Use very fine paint brushes for the stalks and slightly thicker ones for the leaves and flowers. Clean the brushes carefully between each colour.

The inspiration for this lamp came from a small evening bag. Either copy the design used here or find an alternative source of inspiration, such as a piece of fabric, a greeting card or a porcelain plate. Then experiment with the colours you are going to use, colouring in the design with felt tip pens.

Trace your design on to the shade and colour it in using brightly coloured fabric felt tip pens. Edge the motifs in stronger colour. Now paint the design on to the lamp base using ceramic paints. If you do not feel confident about painting the shapes straight on to the surface, draw them on first with a chinagraph pencil.

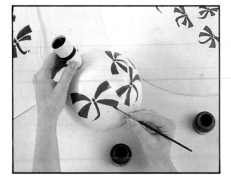

Leave the first colour to dry before edging the design in a lighter shade. You will need to fix the paint on the lampshade by heating it with a hair dryer for a few minutes.

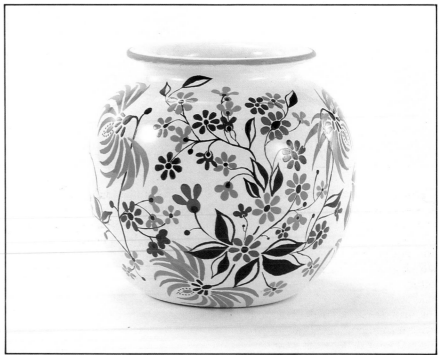

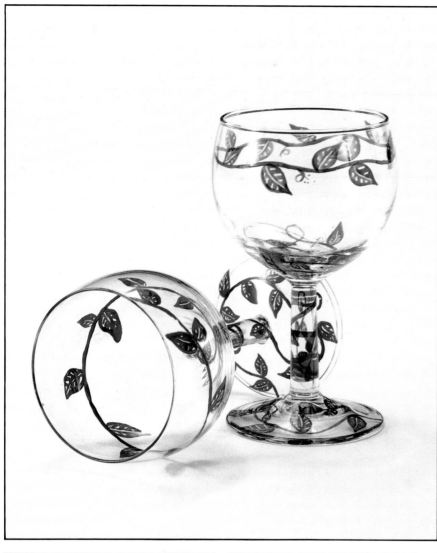

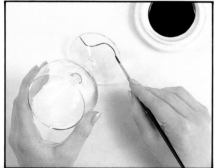

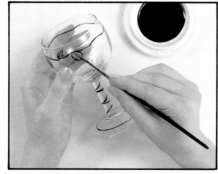

Paris goblets are the cheapest wine glasses you can buy, yet you can transform them into these stylish drinking vessels with no more than a little ingenuity and some glass paints. Working from either the top or the bottom of the glass, paint on a winding plant stem using a fine brush. You may have to leave the glass to dry between painting the bulb and the base so you do not smudge the paint.

Once the stem has dried you can then decorate it with intricate leaves and curling tendrils. Use a very fine brush to achieve a delicate finish.

For those of you who like plants but lack green fingers, why not paint your own plant, cascading down from a wall lamp. Make an outline of your shade on to the wall so you know where to position the plant. Now, using a house plant as reference, draw the design on to the wall. Use a pencil so you can rub out any mistakes.

If you are using a translucent lightshade like this one, you can draw some of the leaves within the outline so that they show through the shade. Paint the leaves using acrylic paints or even artist's oils, though the latter will take a little longer to dry. Use dark colours to create shadow and depth, and light colours to add highlights. Finally, fix your shade in place. As you can see, the effect is stunning.

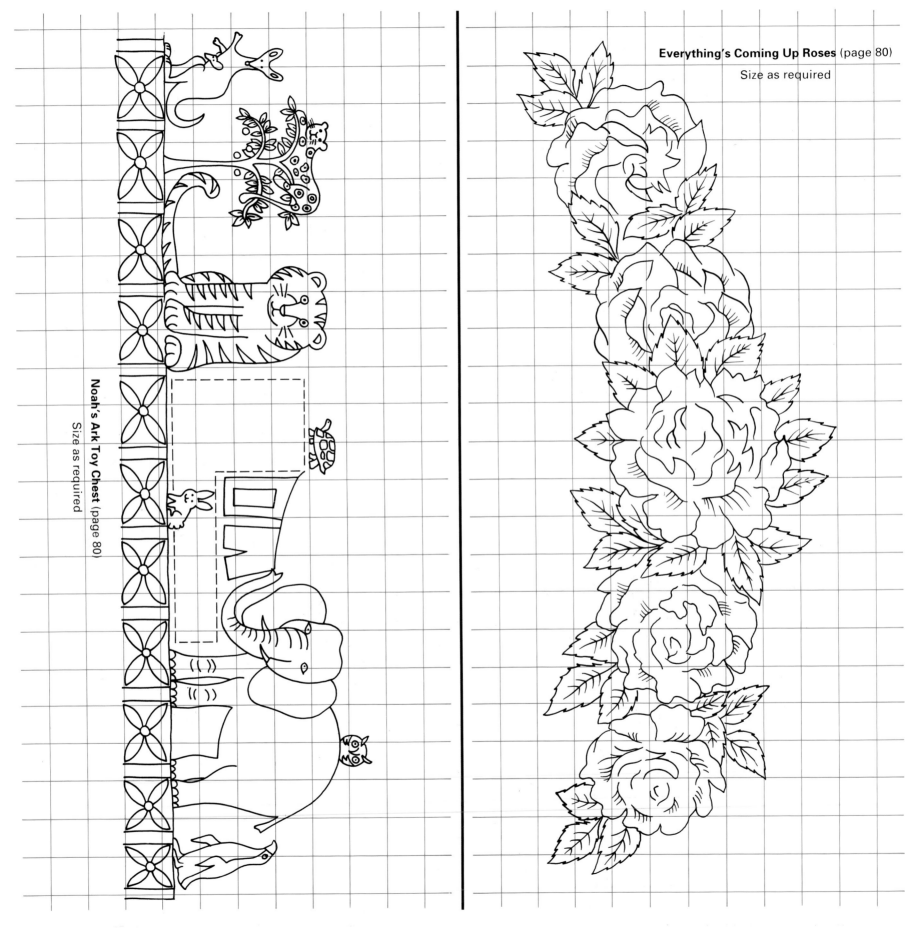

Noah's Ark Toy Chest (page 80)

Size as required

Everything's Coming Up Roses (page 80)

Size as required

Seascape Scarf (page 86) Size as required

Brilliant Boxers (page 88)

Size as required

INDEX

A
A Room With a View **74-75**
Abstract Tablecloth **85**
Art Nouveau Glasses **93**

B
Bamboo Stool **82**
Bathed in Flowers **39**
Bedside Chair **33**
Bluebird Bedroom **32**
Bluebird Border **36**
Bluebird Chest **33**
Brilliant Boxers **88**
Bring in the Clowns **90-91**

C
Cherry Ripe **84**
Colour-Flecked Placemat **63**
Crackle Varnish **77**
Crazy Candle **70**
Curtains a la Mode **71**

D
Decorative Ducks **76**
Decorative Mirror **79**
Design with a Sponge **63**
Designer Chair **72-73**
Dragonfly Lamp **92**
Dreamy Bed-Drapes **34**

E
Easter Basket **69**
Embroidered Inspiration **92**
Everything's Coming Up Roses **81**

F
Fat Cat Border **52-53**
Floral Lloyd Loom **82**
Florentine Border **24**

Florentine Wall Pattern **23**
Forever Spring **47**
Framed in Flowers **47**
Freehand designs **76-93**

G
Garden Pots **42**
Garden Room **10**
Golden Honey Pot **91**
Goosey Goosey Gander **49**
Grecian Tee Shirts **89**
Grow Your Own **93**

H
Hand-Painted Fruit Basket **62**
Harvest Storage Jars **77**
Honeysuckle Bathroom **38**
Honeysuckle Border **40**

IJK
It's a Frame Up **78**
It's a Wrap **48**
Kitchen Lampshade **21**

L
Lacy Bedlinen **50**
Leaf 'n' Column Standard Lamp **83**
Leaf Print Easter Eggs **69**

M
Making an Entrance **22**
'Man Friday' Blind **88**
Marbled Gift Boxes **65**
Marbled Plant Stand **64**
Marbling **64-65**
Marvellous Marbling **65**
Masking **70-74,**
Mediterranean Platter **68**
Mirror Image **54**

N
Noah's Ark Toy Chest **80**

OP
Other techniques **58**
Peacock Salt Box **77**
Potato cut printing **66, 67, 74**
Potato Print Cushions **66**
Potato Print 'Placemat' **67**
Potato Print Giftwrap **66**
Pretend Panelling **25**
Pretty as a Picture **79**

Q
'Quilt' Cushions **85**
Quilted Silk Cushions **13**

R
Rag-Rolled Tablecloth **62**
Ragging **59, 60, 62**
Resist painting **68-69**
Ribbon Bows **35**
Rope Picture Panels **28**

S
Salt on Silk **87**
Seascape Scarf **86**
Sponged Cabinet **61**
Sponged Vase **60**
Sponging **59-63**
Stencilled Flowerpiece **46**
Stencilled Kitchen Units **18**
Stencilled Mugs **45**
Stencilled Tiling **51**
Stencilling **10-57**
Stippling **58**
Strawberry Fare **43**
Studied Elegance **26**
Study Table Lamp **29**

T
Table Dressing **27**
Templates **15-16, 19, 21-23, 35, 39, 55-57, 75, 94-95**
Tie Dying **89**
Torn Tape Plate **73**
Towels to Match **41**
Trellis Pelmet **12**
Tulip Café Set **20**
Tulip Wall Border **19**
Tutti-Frutti Tiles **44**

W
Wisteria Table Lamp **12**
Wisteria Trellis Border **11**
Who'll Be My Valentine? **87**
Write in Style **30**

Z
Zig-Zag Tumblers **70**